The Drawings of
GEORGES SEURAT

Young male nude for "The Bathing Place" · *Jeune homme nu de "La Baignade"*

The Drawings of GEORGES SEURAT

With an Introduction by GUSTAVE KAHN · Translated by STANLEY APPELBAUM

DOVER PUBLICATIONS, INC., NEW YORK

This Dover edition, first published in 1971, con-
tains all the illustrations in the two portfolios of *Les
Dessins de Georges Seurat (1859–1891)*, originally
published by MM. Bernheim-Jeune, Editeurs d'Art,
Paris, in 1928. The full text which accompanied
these portfolios (list of illustrations and essay by
Gustave Kahn) has been translated specially for the
present edition by Stanley Appelbaum.

International Standard Book Number: 0-486-22786-3
Library of Congress Catalog Card Number: 73-131438

Manufactured in the United States of America
Dover Publications, Inc.
180 Varick Street
New York, N.Y. 10014

Georges Seurat

1 8 5 9 – 1 8 9 1

Georges Seurat, for three years, was the young man mad about drawing.

Much earlier, barely out of his childhood, he had tried out his pencil and brushes. The lessons of old man Bin, Victor Bin, mayor of Montmartre, who exhibited a few large historical panels at the Salons, had not taught him very much about the rudiments of painting, but that was abundantly disclosed to him by his own artistic temperament.

What did he expect to find at the Ecole des Beaux-Arts, in the studio of Lehmann, pallid painter of desolate Oceanids? Easy access to models and equipment? He came out of there with a few precise and precious nudes.

No doubt, during his few months of irregular attendance, he often stopped directly opposite the Ecole, at the Louvre!

He was also a student at that peripatetic museum —the exhibitions of the Impressionist painters, in those temporarily vacant apartments in the center of Paris where Degas, leader and organizer, assembled the work of his friends: Claude Monet, Renoir, Sisley, Camille Pissarro, Raffaëlli, Guillaumin, Gauguin, Lebourg, Zandomeneghi, Berthe Morisot, Caillebotte, Rouart, Forain, Eva Gonzalès, Vignon, Vidal. Exhibitions which were demonstrations, in which the Impressionist phalanx never managed to march perfectly abreast.

Seurat and Signac were admitted to the fold (at the same time that Odilon Redon was invited, and the presence of Serret and Schuffenecker was requested) on the occasion of the Rue Laffitte show, which was the finest of the type, but also the last: a swan song. Confirmed glory was being exhibited!

It cannot be said that at the time Degas did not like Seurat. The great painter enjoyed having friendly discussions with his young emulators, but remained distant. He liked to bestow epithets on the young initiates of Impressionism. He called Georges Seurat "the notary."

Why? Because Seurat, toward evening—at nightfall, in fact—correctly dressed and wearing his top hat, would slowly follow the course of the *boulevards extérieurs*, from the Place Clichy to the Boulevard Magenta, until he reached home and dined punctually with his family.

After that, he would often go to a vaudeville hall and sketch.

But Degas did not know the morning Seurat, who would put in some time working and then go off to have the quickest possible lunch at any restaurant he happened upon in his neighborhood. On his head would be a soft felt hat with a very narrow brim and crushed down at the neck. He would wear a short jacket and look as unaffected as he could be, although his great height, the severe regularity of his features and the contemplative calm of his glance unfailingly gave him a serious appearance.

I believe that while still quite young Seurat was already obsessed by a strong desire for new approaches and that he immediately and passionately began to look for his own personality.

That is the usual course taken by talented young people. There is no young man possessed by latent originality who is not disposed to show it publicly, or, for the lazier ones, to let it burst forth.

But Impressionism was chosen soil for this ardent quest after individuality.

Born of a refusal to bow down before any attempt at domestication, Impressionism was unable to discipline itself. There were visible signs of respect, of deference shown by the younger men to their elders. Influences were exerted. Imitation was jealously avoided; there was also a spirit of revolt. The younger

artists were convinced that they were making a contribution to Impressionism, and were not afraid to say so.

The enormous diversity among the pioneers of the movement (which had been duly documented by some bitter remarks, not all of which were made by Degas) seemed to indicate to the younger men that it was not enough to paint well, but that it was also necessary not to paint like someone else.

The Impressionists were not really a coherent group, but a number of independents who had come together. The protagonists and adepts of the movement were united by aspirations, admirations and hatreds felt in common and a persecution which they shared. All of them were in firm agreement in their taste for what was modern and alive, their search for a supple technique for painting the spectacle of the world directly as they saw it, and their disgust with the old gods of historical, anecdotal and vignette painting. Manet's artistic desires were different from those of Degas and from those of Monet, whose emotion was not aroused by the themes dear to Renoir. Pissarro followed his own path, as did Guillaumin. There was rarely any news of Cézanne. Raffaëlli was an outsider from the start.

At times, within the genuine comradeship of the group it was possible to discern particular affinities, lasting or transitory: personal dialogues in the midst of the general movement. The names of Monet and Sisley, of Guillaumin and Gauguin, were coupled, just as those of Seurat and Signac were. And then the situation changed. In order to be spoken of as Gauguin, alone, without Guillaumin attached, Gauguin went off all the way to the Antilles. It was not only their nature, it was the glory of the Impressionists that they were individuals, different from one another and original because they followed a variety of paths, the apparent similarity of their techniques being only the reflection of parallel ambitions and the celebration of the same cult of light. From the very beginning, there were some who took different directions and never returned: Fantin-Latour, Whistler, Cals, not to count Carolus Duran.

Thus, extreme variety. Variety is a bit like disorder. Georges Seurat's mind was particularly fond of order. He would have established methodical procedures if there had not already been examples before him.

It appears that the two predecessors he basically admired at the outset of his life were Monet and Renoir. It even appears that Renoir's technique appealed to him more than Monet's. I am not speaking of his admiration for museum masters as different as Murillo, Holbein and Vermeer; that is just getting acquainted with the past. His strong liking for Delacroix was more of a real influence. But his immediate masters were Monet and Renoir.

In the laudable tradition of Impressionism, equality could be achieved only by outshining previous work, or at least by doing something different.

Was Seurat already obsessed at the start by the idea that painting cannot follow a variety of formulas, that beneath the appearances so brilliantly captured there is a law, that whoever discovers this law will find the secret of painting?

After Renoir had painted the admirable portrait of Madame Charpentier, one of the finest examples of Impressionism's conquest of modeling and relief, did Seurat ask himself whether it were not possible to go farther in that direction of supple and variegated sculpture in paint? He believed that draftsmanship was the essential element in painting, that color harmony had to proceed from linear harmony. He wrapped himself up in drawing. This was a condemnation of the felicitous snapshot, the notation, magical as it might be, of the passing moment. A different and new theory of art was being drafted. Delacroix was relegating Turner to the background. On the day when Seurat devoted himself to drawing for years to come, Neo-Impressionism began.

When Mallarmé, in 1888, published in the *Revue Indépendante* a translation of Whistler's lecture "Ten O'Clock," the readers, well acquainted as they were with Whistler's work and his cult of "nocturnes" with variously dark and light areas, were still somewhat surprised to find him formulating the axiom that the painter is primarily able to practice his art at the hour when artificial lights are turned on. This was almost anti-Impressionism, even if one of Monet's most valuable canvases had depicted an illumination in a narrow street on the night of a national holiday. After all, the Impressionist painter generally rose with the dawn to capture the glitter of dew on flowers and grass and took great care to be present when the sunshine was most spectacular of an afternoon. Seurat and I spoke about this lecture one fiery summer day in that little studio on the Boulevard de Clichy in which he completed a large canvas every two years, working so ardently and in such overwhelming heat that he would lose a lot of weight in the process. Seurat said

to me: "That is a remark only a great painter would make. Whistler is right."

Besides, Seurat had already undertaken the preliminary drawings for *La Parade* (The Outside Show), projects for circus pictures, studies of lights in streets at night, of the lighting in a dressing room. He found in Whistler's theory not so much a lesson as a confirmation of older and perhaps primordial insights.

When he began his confinement in the realm of draftsmanship, he was already obsessed with the magnificence of the night, and also with its solitude, and he was not as insistent as Whistler that the darkness be riddled by lights.

Perhaps Seurat, a reader of naturalist novels, recalled the opening of *Le Ventre de Paris* (The Stomach of Paris, by Zola) with its spellbinding description of the wagons coming down the Champs-Elysées in the poor light of that period, after crossing the thick shadow of the suburbs, moving at the speed of their horses—horses accustomed to following the same mechanical route blindly and drowsily. Several times he studied the movement of wagons in the blackness which was barely growing pale, by the tiny light of the lantern that gave horse and cart the semblance of some fantastic beast.

If Seurat was the painter who introduced less obvious "literature" into his work than any other, he should nevertheless not be thought of as a slave to paint, insensitive to the counsel of other forms of art. In conversations with me, he was very eager to know whether his new approach to painting might be similar in technique, or at least analogous in intuition, to the art of Wagner.

There are still traces in his work of that realist influence which made itself felt so deeply in Impressionism, the ascendancy of that naturalism which was sufficiently complex and supple to embrace, often, the deformation of the image by light. Besides, even though he was an individualist, he was a reader. In addition to the literary works he enjoyed, he had absorbed all the books on art history and technique that he came across, and I was able to observe that his knowledge of Charles Blanc was unequaled (not to count Rood, Chevreul and all the theoreticians of light whose experiments and declarations were passionately studied by the Impressionists).

It would be wrong to define too precisely the literary influences on an artist who was as deliberately and exclusively a painter as Seurat, but it is fairly certain that he was not totally impervious to them, to the extent that they confirmed his instinctive perceptions, which in his mind quickly became fixed patterns of will.

His few early drawings (were they not done before the period of his confinement in draftsmanship?) prove that he visited the museum. But why was Holbein the chosen master (Nos. 12 and 13)?

Was it not because he is the painter who best achieves sculptural truth in motionless figures? Was not Seurat already concerned with the soberness of gesture, different from hieraticism and yet not far distant from it? This soberness does not possess the religious element of hieraticism but, equally fervent, it contains a sort of mystic feeling which strips away all that is accidental and transitory in the fleeting phenomenon and captures all that is fundamental and essential in it.

To transcribe in this way is to attain the very heart of things, to celebrate beauty and expression, to tremble with an oppressive emotion at the power of reality, to enjoy an almost total communion with the most intense feeling of life. In that way Seurat shares somewhat in the anxieties and desires of those among his literary friends who were the Symbolist poets. The full presentation of a truth, disengaged as much as possible from attendant circumstances: that is the symbol.

It is not solely the coincidence of living at the same time which creates those companionships between painters and writers that last a few years, come to an end, become famous and gild a moment of the past, making it seem a golden age of comradeship and unselfishness.

The force of youth and the attraction exerted by high hopes help to bring such groups together, but intellectual points of contact often make these artistic encounters more logical, the group more coherent and the alliance more justified than might be thought at first.

The Neo-Impressionist painters were associated with two very different groups of writers. One group grew out of naturalism and continued to give the Neo-Impressionists the old affection they had felt for the first Impressionist masters in the heroic days of the Café Guerbois.

Paul Alexis' friendship with Seurat and Signac was an extension of Zola's with Manet, and if his defense of their art was sometimes weak, that was purely a matter of temperament: Paul Alexis was no fighter.

The other group, the Symbolists, Paul Adam, Jules

Laforgue, myself, the whole branch of Symbolism that was enamored of modernism, firmly based on intellectuality, liked Seurat and Signac, for other reasons. Certainly we felt a lively admiration for their predecessors, which was increased by our youthful emotions (for we were quite young and just embarking on our intellectual life when we were thunderstruck by their exhibitions and also by the permanent presence of some of their masterpieces in Durand-Ruel's windows); yes, they were the men who had violently opened the window for us, revealing spaciousness, beauty and light.

This enthusiasm for Impressionism was not entirely exclusive. Sparing as we were with our admiration, we gave a share of it to Puvis de Chavannes and Gustave Moreau. But was it merely because of their legendary color? Much more than that, we were drawn to the majestic simplicity of the one and the florid and sumptuous hieraticism of the other. We were not changing our opinion by admiring Seurat and Signac. Not only did we feel esteem for each other as leaders in the fight for new ideas; there was an aspect of their work that was attractive to us and which seemed to parallel our efforts: that static element, that attempt to penetrate to the absolute, which characterized the art of Seurat whether he was painting or drawing figures.

We were atune to the mathematics of his art. Very possibly the fire of youth inspired us with the near-certainty that his researches in line and color presented definite analogies to our theories on the verse and the phrase. The theory of discontinuity might well have some relationship to the theory of optical mixing. Painters and poets were mutually delighted to think so.

Would we have thought more or less of Seurat if he had enclosed his creation in a literary formula instead of creating pointillism? Perhaps it was not altogether for the same reasons that we admired the Delacroix paintings in Saint-Sulpice which we often went to look at with him and Signac. We did not discern divergences in the expression of our opinions.

Besides, is pointillism basic to Seurat's work? It is much more than a technical procedure. It is a method, a discovery. It is not the very essence of his art, the entire revelation of his intelligence.

Would Seurat's pointillism have been the last word in his technique? To judge by the example of Paul Signac: yes. But as fraternal as these two painters were, they were two different men and each was strongly individualized.

When considering a brilliant painter who died at the age of thirty-two, it is always possible to foresee a future development. For Seurat, there is no way for us to be precise about this or even to imagine what might have been. His pointillism was becoming more and more alert, free, radiant. He died full of affection for his technique and pride in it, but he died on the threshold of his maturity.

Seurat was in a way related intellectually to Stéphane Mallarmé in his passion for logic, in his eagerness to make the work of art a mental construction in its essential lines and, at the same time, to bring it face to face with visible and tangible reality.

This resembles the squaring of the circle. It is somewhat like cutting a thread and trying to tie it together again.

Nevertheless, that is the problem!

Mallarmé had been a Parnassian and could not forget the solid ground plans (never firm enough to suit him) on which he had built his first poems, before he came to cherish illusion, analogy and immateriality above all else.

Seurat retained something of the realism of his training in its aspects of fullest truth; his idealism did not prevent him from desiring to bring his paintings face to face with nature.

Now, presented with the flowing atmospheric river of phenomena, the artist is compelled to build a dam around a pictorial subject if he is to capture it.

In practicing his craft, the painter starts out with a canvas, square or rectangular. When he has filled it, what becomes of the rays which his creation casts onto the world outside the picture? Above all, what becomes of the tonal relationships which a logical orchestrator of color has placed on this canvas and which can be extended beyond the canvas?

The past and the present give the painter the simplest advice. He is to stop brutally short by cutting off the picture edges clearly with a frame. A shifting vision is imprisoned within hard gold lines. The Neo-Impressionists replaced the straight gold line with a white barrier, slightly undulating, but a barrier all the same. To solve this insoluble difficulty, Seurat conceived his painted frame, with which he surprised his colleagues as much as Mallarmé astonished the poets when he declared that since a collection of poems is made up of unrelated pieces, it is improper to give them the continuous appearance of a book, and that it is preferable to enclose them as unbound sheets in a box, which could be of splendid workmanship.

Thus Seurat continued his harmonies onto the wooden border of his picture. Then he found that inadequate and imagined an orchestration of tone shaded off more thinly and vaguely on a second border which would project slightly past the first one. It always seemed to him that, try as conscientiously as he might, he was still brutally ripping an episode out of context, tearing a page of art out of life. In what direction would he have developed in regard to this problem? He was not one to cease trying to solve a technical difficulty when logic was at stake.

Seurat's drawings can be placed in two categories.

One group, the smaller one, consists of drawings which already contain the idea of the paintings which he would create from them. These are preliminary drawings. Except for one or two, which show the first idea of the nude boy (page ii) and the sleeping man (Nos. 106 and 107) of *The Bathing Place*, they were done after Seurat had stubbornly withdrawn into draftsmanship.

The other group consists of drawings complete in themselves, worked out for their own sake.

Within this group there are again two divisions: a great number of drawings in black and white and a very small number with highlighting or done with colored chalks.

These color drawings were nearly all made at the vaudeville hall. Their notation is very complete. Seurat's originality is evidenced by the already quite summary outlines of the figures and by the gradation of the deep semi-dark areas which tend to fuse into black and white as they move away from the figures.

One of the characteristics of Seurat's drawings is that they are done not so much for the line as for the atmosphere.

The charcoal, applied vigorously in massed areas, leaves along the contours patches of gray and snowy white, archipelagos of subtle tonalities shaded off from white to blackish in a slow flow, an edging which the detail of the values turns into a lightly tinted borderline. At times the drawing is conceived for the sake of the atmosphere, as in the few flower arrangements which Seurat formulated, without defining them too clearly, in a wide cloud of dust. He modeled them by means of the atmosphere. Moreover, all his drawings, even the tightest and strictest ones, those in which the precision of a silhouette is more in evidence, even when they interpret an actual model, are ascribable to the Impressionist technique, with the novelty and originality which Seurat adds to it.

With the exception of a few beautiful drawings, of which the most noteworthy is the portrait of his mother (No. 83), a drawing which was worked out to achieve a complete, authentic, Holbein-like portrait, it is the impressions Seurat received—with due regard to imagination, variations and optical illusions—which he tried to set down on his sheet. There is almost never an attempt to indicate a particular motion. Most of the time he conveys static forms. Naturally, not all the drawings obey that norm. If he wants to retrace and hold fast the parallel movements of two dancing women, the antithetical movements of two fighting men, he will supply the tempo and rhythm along with the form, but most frequently his drawings are notes jotted down about people with the desire to make an abstract of their fundamental lines in light.

That does not preclude a variety of subject matter. Here, we find an isolated person, like that sleeping man whom Seurat drew twice (Nos. 106 and 107) in an attempt to seize the variety of the contours, the special quality of motionlessness, the element of slackness and fatigue; or else we find, in the evening, in the Parisian night, an almost spectral procession of forms stylized by the darkness in front of an illuminated shop window. They are tall figures of young women similar to those he will reveal in *La Grande Jatte*. Moreover, he sought to stylize the current fashions.

In 1883, in 1884, the years of his headstrong drawing fever, the caprices of fashion did him a disservice. After the elegant style of the sheath dresses there appeared that extraordinary caprice of the large bustle (*tournure*), an enormous exaggeration of the small bustle (*pouf*) which preceded it—a sort of rigid seat attached to the woman's back. Fashions are rarely a complete disaster. This time ugliness was outdone, and Seurat, a good Impressionist with a passion for truth, attempted to make this costume hieratic. He came directly to grips with the disastrous profile. No overloading, but no timidity. He placed the model in profile, brought out the curve of the back which the dress designer wanted to obtain, and captured all the bizarre fantasy of the get-up.

It was an unfortunate coincidence that the fashion was so hostile to him, but what could he do about it?

The exhibition of Seurat's drawings included an eminently interesting item. Along with a handful of academic nudes he had kept, this was the sole trace of his student productions, the sole trace of his quest (no doubt imposed by his environment) after success as a student. This small drawing indicates to some extent

what Seurat would have done if the ascendancy of modernism and the enthusiasm for the spectacle of life had not so swiftly led him far away from archival and anecdotal painting.

The given subject: "Ulysses returning home and surprising the suitors" (No. 10). This drawing by Seurat already shows a desire to be methodical in the composition of the sheet and an attempt at soberness in the attitudes of the figures. He did not think of complicating the action. He could have rendered a disorderly crowd of people hurrying out of the range of the cruel arrows. He reduced the episode. His interpretation is not at all romantic. It is not that of a classical artist, either. A classical artist would have attempted to adorn the foreground with some sorrowful and sympathetic group, to describe a beautiful gesture of entreaty or agony based on Greek sculpture. A classical artist would have sought after dramatic and moving contortions of the arms. Not he. He imagined the unexpected entrance of Ulysses into the hall where the suitors are feasting. He attempted to give the suitors, whom he reduced to three, the simple and truthful attitudes of surprise. He took in only a moment of time. He did not unfold the action by facets which, appearing simultaneously in the drawing, would suggest the succession of events in time. He evoked a realistic scene on a legendary theme. His mind already knew something about its future. There were already some lineaments of the form, some instinctive awareness of the formula to come, an intuition of his future quest after simplicity.

Let us leaf through this album of drawings, taking those in which we find more fully confirmed that precocious maturity, that powerful balance allied so closely with the fever of research—the principal characteristic and the dominant of Seurat's esthetic physiognomy. For it should never be forgotten that Seurat was twenty-four when he finished *The Bathing Place* and twenty-six when he asserted the theory of a new art in *La Grande Jatte*.

Among the beautiful drawings reproduced in this book there are some, and some of the most complete ones, which were the work of a young man of twenty-one and twenty-two. It would be difficult, perhaps, to assign an exact date to each one and to determine their order. Certainly, the boy of *The Bathing Place* is among the purest. Among those which best demonstrate the artist's power of observation and also his creation of a new method for realizing his vision, the studies of the sleeping man must be included. But outside of these rare examples it is not easy to define a progression. From his first drawings, he knew where he was going and what he wanted; rather than progress, what we find is application of his research, mentality and procedures to more complicated or more schematic themes.

Among the most beautiful drawings, some are devoted to the examination of details, like the study of folds in a cloak thrown over a chair, so patiently studied in the reflections of its sharp angles and drooping areas (No. 11); the fine male torso (No. 62); the numerous studies of faces half-illuminated, half-shaded by a lamp (No. 97), entering the multiple indecisiveness of reflections on a partial accentuation of the contour. Note also that image of two people seen from behind moving off into the dusk, which is reminiscent of lines by Baudelaire (No. 84).

In the altogether modern vein, there is the simple and lifelike gesture of the woman who wants to protect her skirt from the mud and raises it (No. 143). As part of the quest for optical illusions or, rather, for truth in optical illusions, as part of the desire to set down, in believable form, the mute face which objects sometimes present, there is the "haunted house" (No. 132) with its extraordinary white cube under a sky in which the clouds passing by almost appear to have regular forms.

In contrast there is the lively and witty study of a man whitewashing (No. 51).

Among the strictly realistic portraits, there is the one of Paul Signac (No. 67), caught with all his youthful animation, with his pervading air of level-headedness, which becomes imperturbability in that British-inspired costume—an astonishing evocation of the Signac of that time.

Then there are the studies for the *Models Posing* (the painting was later), which successively lead to more and more expressive prettiness in the physiognomic study of the models (Nos. 118 and 119). The nude (No. 82), reminiscent of one of the most beautiful and discreet painted by Fantin, is also doubtless a study for the *Models Posing*. The powerful silhouette of the man on the scaffolding (No. 61) is a testimony to a period of realist esthetics, discovering the beauty of physical labor; the robust slenderness of the architectural framework is a testimony to that idea of Huysmans, who was read and consulted by all the young painters of the time, that the scaffolding is always more beautiful in its lines, in its slender latticework, than the building it helps to construct. Here are

people fishing (No. 111), in the décor of the Grande Jatte, perhaps introducing the first idea for the painting; the woman with a dog (No. 128), in the Parisian morning, with such a firmly planted step that she seems overbearing. Also that study of luminous sunbeams (No. 98) above and beside the houses which they plunge into night, a regularized and growing perturbation of shadow on the street; the vagabonds under the bridges (No. 57).

Among the very small drawings, there are many curious notations, and that last drawing which is so touching because it is the last known: a clown's hand (No. 123).

And the interesting thing is that, in going through this mass of drawings, one finds no influences. They are completely personal. The hand followed the mind in its journey through new mental conceptions. The fever of the quest never disturbed the studied firmness of the execution.

It was only at the end of this period of draftsmanship that Seurat's group—called the Neo-Impressionist group by its adepts, the pointillist group by some critics and the confettist group by the Salon painters —began to be organized. The first adept was Paul Signac, still very young, already the possessor of a skillful and lively mastery, enamored of independence, at first an admirer of Guillaumin for the realistic verve of that fine painter. Signac looked at the *œuvre* Seurat was beginning to create, took a liking to his method and decided to place in the service of scientific harmony a spontaneous temperament, the most magnificent gift of sudden, varied, picturesque, complete vision, an exceptional capacity for improvisation and rapid transcription, of which the bouquet of colors in his watercolors and the admirable firmness of his drawings still furnish the proof.

Then came a recruit of the highest quality, a master, a veteran, Camille Pissarro, his long beard already completely white, his face sculptured into the most beautiful traditional semblance of God the Father, patriarch of a numerous tribe, the eldest of whom, Lucien Pissarro, he immediately won over to Seurat's technique. He was the only one of his children already old enough to make a name as a painter.

From his first canvases, in which Corot-like tenderness was combined with more precise firmness, Pissarro had not ceased looking for new approaches, while continuing to turn out pictures. His etchings bear the trace of experiments which he did not bring

to a conclusion in his paintings. He was no enemy of composition; he remembered that Cézanne had thought of illustrating *Orlando Furioso* with large color drawings, but he wanted composition to be realistic, plausible, contemporary. He lent geese swimming on a canal the majesty of swans, but he was careful not to ennoble the form of his geese or to lengthen their neck. Skilled above all others in rendering in horizons the crowding lines of receding hedges and curtains of trees marking the distance, he was enamored of modeling— modeling by light—in his figures, and in Seurat's technique he found the instrument he dreamed of. He became an ardent propagandist for his young emulator. He defended him in word and by beginning to paint like him. It was in vain that his dealers and collectors, disconcerted by this sudden and well thought out development, entreated him to return to his cabbage patches, to his little suburban gardens with their dazzling weightless flowers, to the symphonies in green of his Normandy meadows, to his crowded markets, so stirringly beautiful in their unity of composition; the old master was stubborn. When, later on, in his views of cities, Paris or Rouen, he went back to most of the procedures he had worked out for himself since the outset of his career, he still used some of his pointillist technical feats in his skies.

Successive exhibitions brought to the group several painter friends who inclined toward Seurat's method while still maintaining their artistic freedom; one such was Angrand, who participated in the first shows of the Independents (the one in the wooden building in the Tuileries) with large, vigorous views of the Seine.

Dubois-Pillet, the organizer and at the same time the real creator of the Independents, borrowed Seurat's technique to paint views of Meudon waning in the dusk, moored lighters motionless on the detailed enamel of the waters, and also large figures like the *Woman Carrying Bread.*

Then Luce, arriving with figures dashed off with the vigor of Guillaumin and perspective landscapes with red and russet roofs amid bright foliage, came under the domination of Seurat's and Signac's logic from the first year that he exhibited with the Independents. Under the influence of Puvis, in the realm of figure painting and delvings into realistic color harmonies, he altered the nature of his art, but his pointillist period elicited some fine paintings.

Henry Cross, who was to make color sing so harmoniously and with such variety, had arrived among the

Independents with experiments in epitomized prettiness, in which the inflections of feminine curves played the main part and supplied the chief attraction. A taste for elegance dominated his large vignettes, which he abandoned forever in order to call forth a wealth of varied tonal harmonies in carefully composed songs on canvas by the shores of the Mediterranean.

Then Seurat's method and the influence of his personality conquered Belgium. The exhibition of the Twenty, which assembled in Brussels the beautiful artistic efforts of Paris and Belgium under the sponsorship of Octave Maus and Emile Verhaeren, became the exhibition of Neo-Impressionism, with Seurat, Signac and their friends and adepts of that country, Van Rysselberghe, Lemmen, Finch, Schlobach and others. At the time of Seurat's death, it seemed as if pointillism might conquer the world and make itself felt in all future developments.

Must we admit that no principle is general enough, no formula vast enough, to embrace art in its entirety? All artistic and literary schools have lost part of their powers in the course of time. The essential thing is that they should represent, as was the case with pointillism, a vigorous, powerful and independent effort.

Besides, do even the boldest creators of a formula and a style follow their desires to the limit immediately? Despite their admirable serenity, Seurat and Signac did not complete their search. While Signac, very attentive to the esthetic theories of Charles Henry, was finding new directions for the harmony of his backgrounds, as in the famous portrait of Félix Fénéon (whose work *The Impressionists*, published by *La Vogue*, was then the conscientious, intuitive and complete manifesto of Neo-Impressionism), Seurat seemed to want to fight, by making progress in his technique, against certain attacks that had been made on him and his partisans.

The stumbling block of pointillism, certain critics alleged, was the nude, the presentation of the human figure. It would seem as if Seurat wanted to answer this objection with his *Models Posing*, in which the dots of color, smaller and smaller, juxtapose such subtle values that the eye, gripped by the general harmony, is no longer held up at the very start by the elements in the construction. As the number of Seurat's works grew in the course of his brief life, his workmanship became less and less obvious and the well-modeled forms were increasingly bathed in a light with unceasing and imperceptible gradations. His technique, grown much more subtle since *La Grande Jatte*, was handled in a variety of ways in his last works, in accordance with the theme of the painting; even though the procedure is the same, in the *Models Posing*, where the women blossom forth like human flowers in close proximity to the still lifes, which are treated with more sculptural relief, in the attenuated light of full day, the brushwork diffuses this light, whereas in the nighttime paintings the light is concentrated.

Moreover, the influence of a great painter is not merely the literal one. I mean that the admirers of a master who live in the subsequent art period do not accept his direction entirely. It is logical that even after coming under the ascendancy of a guide and submitting to all the instruction to be found in his pictures, his disciples are eager to follow the chief advice of the Impressionists: not to paint like someone else. To accomplish that, the primary concern is to avoid a perfect external resemblance and not to accept in full a procedure as dictatorial as pointillism. There is a tendency to reject what appears on the surface and to rediscover the underlying laws of the creative artist's development.

What would Seurat have been without the pointillism that invests all of his work? That is a question which all the artists of value who came after him asked themselves. There are very few who accepted his method of color harmony. But they retained his desire for modeling, the strength of silhouette of his figures and the skillful gradations of his backgrounds; most of all, they admired that silent majesty of Seurat's entire *œuvre* and wondered how, starting off with pure nature, strictly expressed, he had been able to render nature more beautiful, to write the painted poem of the flesh, in real light and in artificial light.

The groups which have succeeded the Neo-Impressionists claim Seurat as a forerunner, just as the Impressionists counted Corot among their precursors. The appearance of the paintings has changed: that is development. The ideas, too, are taken in somewhat different meanings: that is also development. I do not know whether Seurat, if by some miracle he had learned that the Cubists placed him in their chain of influences after Courbet and Monet, would have been extremely interested in their work or would have acknowledged them as descendants. It is a recognized

rule that precursors do not recognize their true disciples, those who take up their effort of renewal where the predecessors left off.

It is also possible that an influence may not be exerted very opportunely and that those who accept it may deform it quite considerably.

The essential thing is that the glory of an artist shine forth, that his teachings be recognized in works seemingly far removed from his, that the creators of these works admit this. Seurat's discipline has influenced most of the fine painters now living. There are scarcely any who have not been obsessed by the majesty of his figures, by their marvelous stature in the light. There are none who have not been deeply moved by the painterly quality, by the touch of perfection with which he balanced his values, and by the poetical and simple strength he managed to give to his admirable drawings in black and white.

All these drawings were assembled, complete and in good order, with a very well prepared catalogue, at a recent show at the Galerie Bernheim-Jeune, which was a continuation of the series of shows which their admiration for Seurat's work had led them to organize in 1908, 1920 and 1926. Several masterpieces by Seurat can still be admired in their gallery, especially that *Parade* [Outside Show; now in the Metropolitan Museum, New York], the genesis of which was explained above. By adding to their collection of art books this admirable group of Seurat drawings, they have recorded a little-known but supremely important moment in present-day art, in French art. These drawings will be scattered among collections not all of which are in France. Art lovers will find them again in this complete album of faithful reproductions, in which all the beauty of Georges Seurat's drawings is captured.

GUSTAVE KAHN
1928

L I S T O F D R A W I N G S

The Drawings

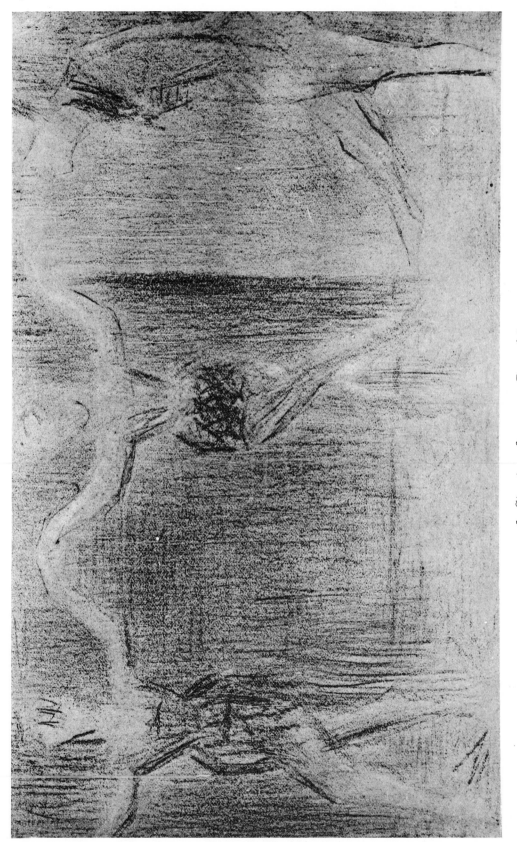

1. Street performers · *Banquistes*

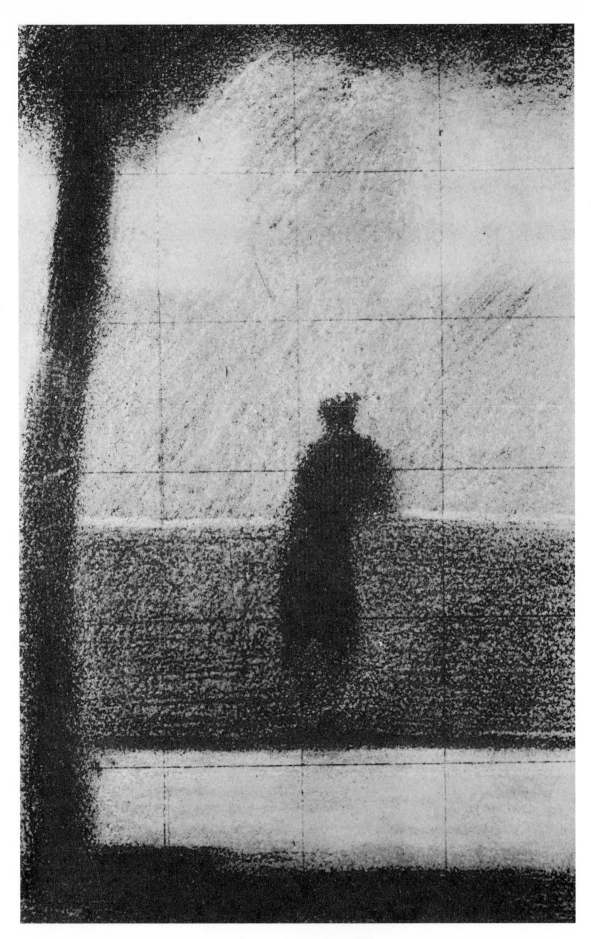

2. The invalid · *L'invalide*

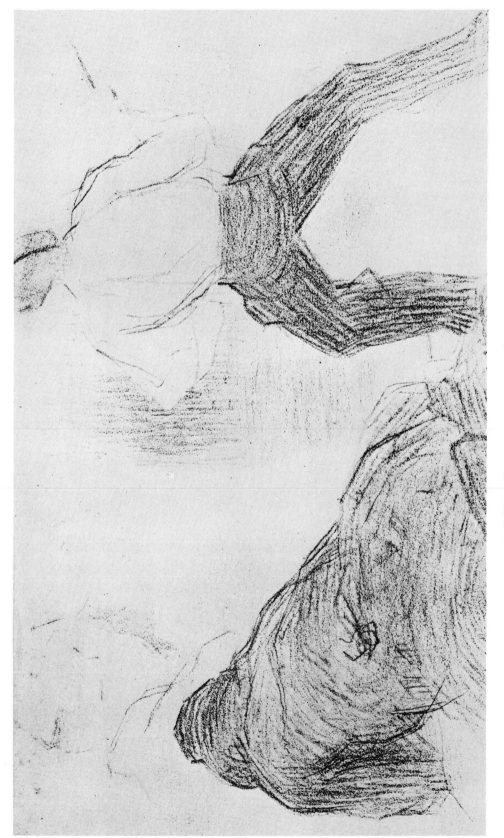

3. Soldier fencing · *Troupier à l'escrime*

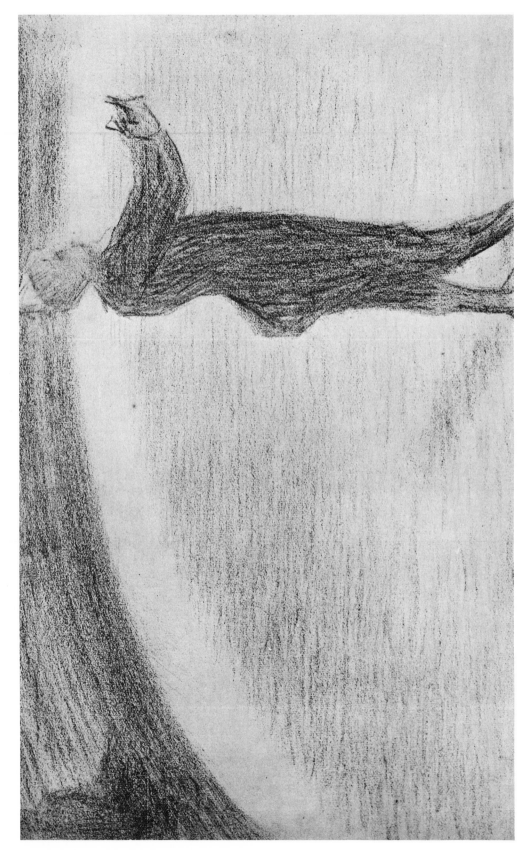

4. The clown in red · *Le clown rouge*

5. Lawn · *Pelouse*

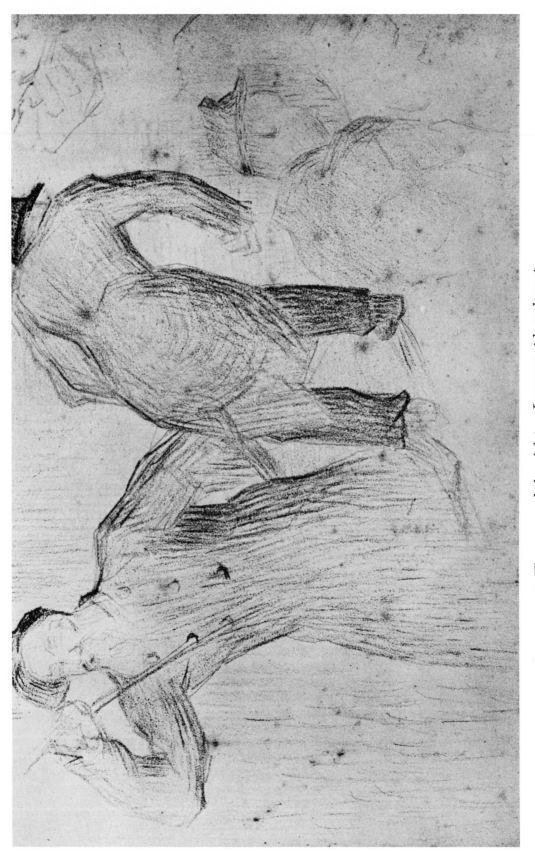

6. The cane and the piglet · *La canne et le cochonnet*

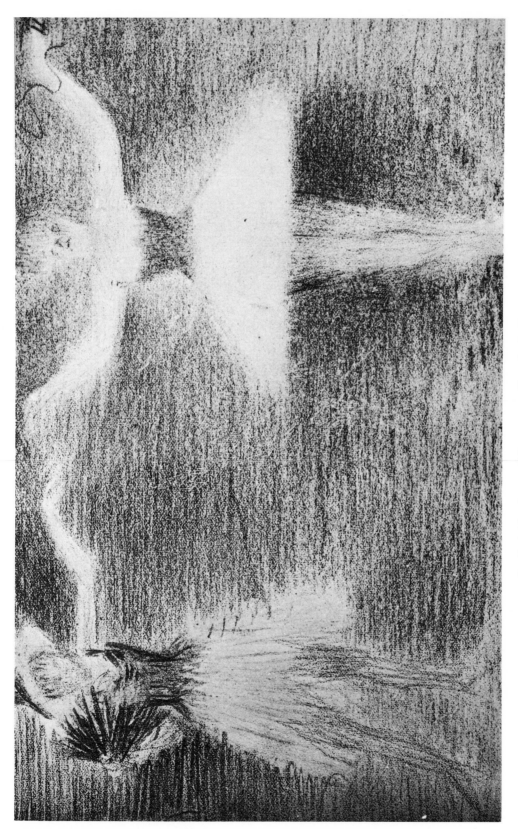

7. Outside show of dancers · *Parade de danseuses*

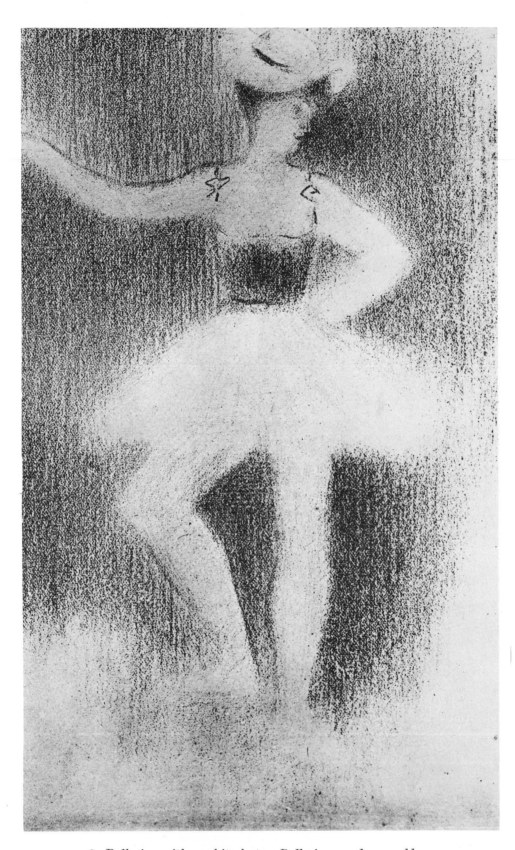

8. Ballerina with a white hat · *Ballerine au chapeau blanc*

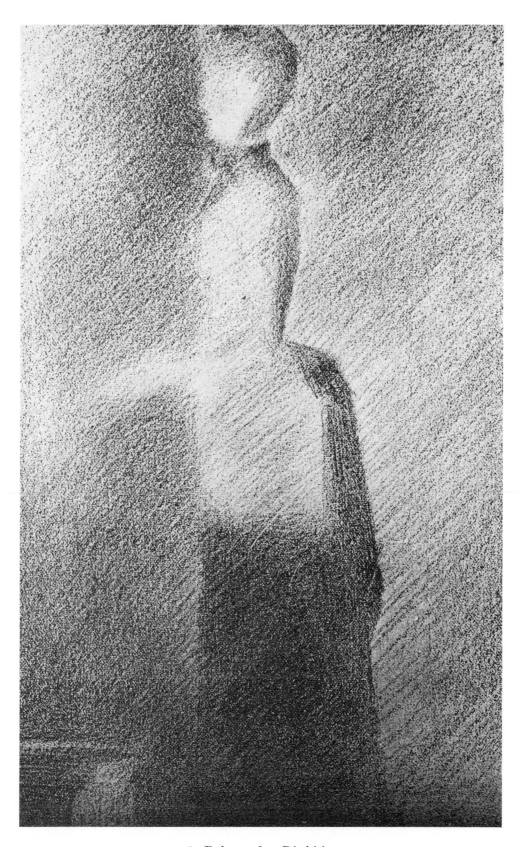

9. Rehearsal · *Répétition*

10. Ulysses and the suitors · *Ulysse et les prétendants* (1876)

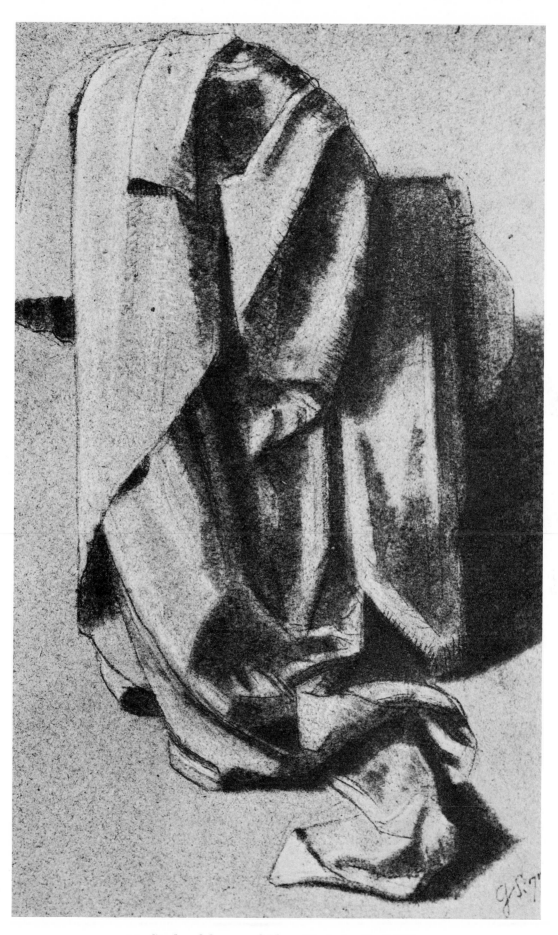

11. Study of drapery folds · *Etude de plis* (1877)

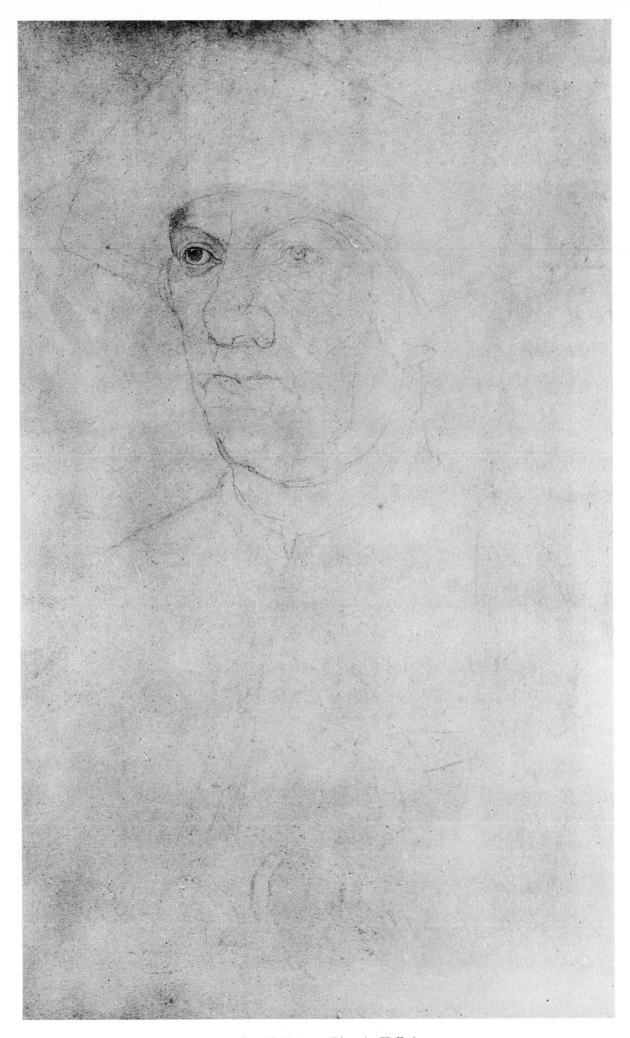

12. After Holbein · *D'après Holbein*

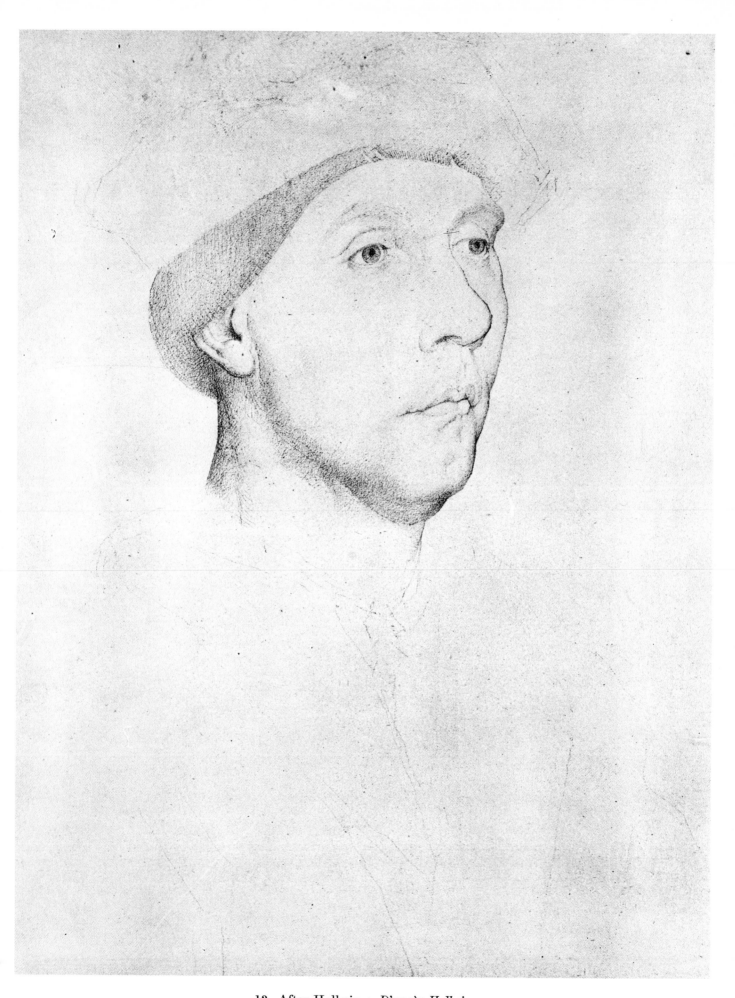

13. After Holbein · *D'après Holbein*

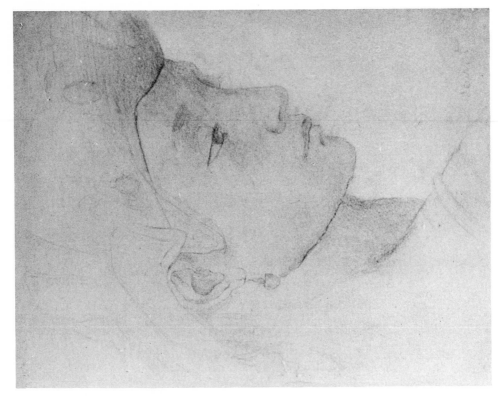

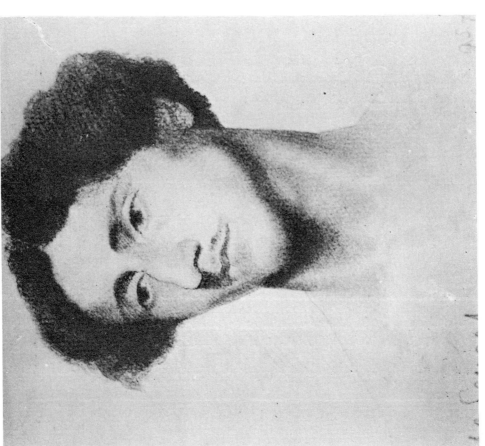

14 & 15. Two heads · *Deux têtes* (1877 & 1874)

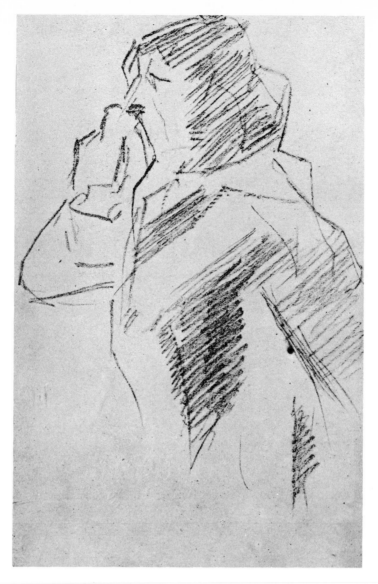

16. Chin in hand · *Le menton dans la main*

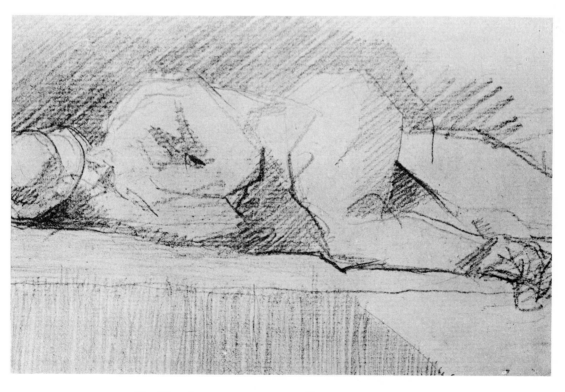

17. Sleeping on a parapet · *Couché sur un parapet*

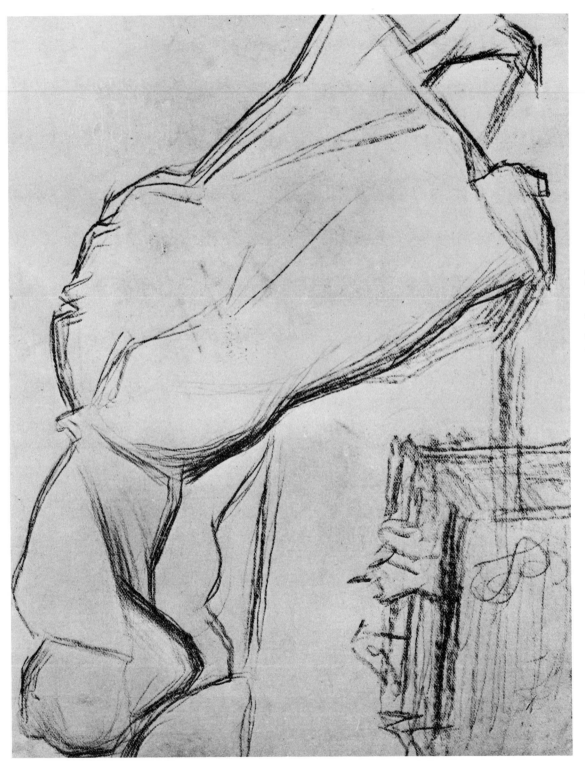

18. Semirecumbent · *A demi couchée*

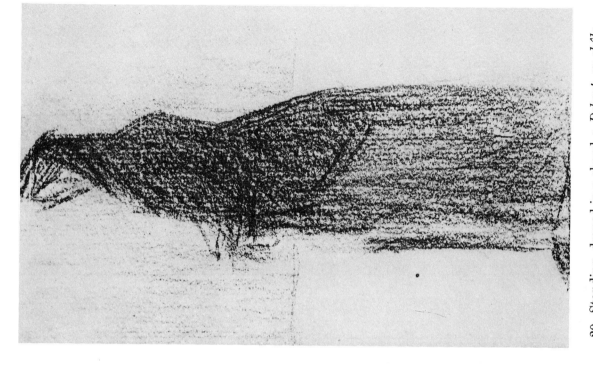

20. Standing, draped in a shawl · *Debout, en châle*

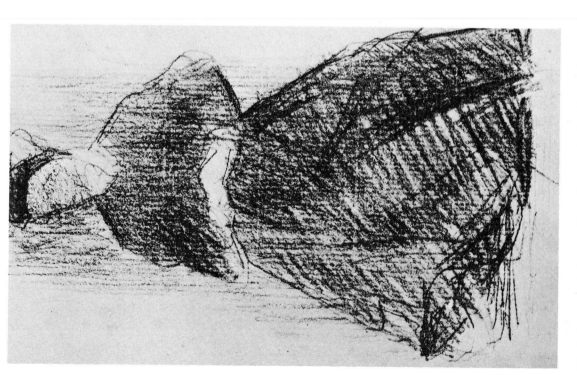

19. Seated, one hand over the other · *Assise, les mains croisées*

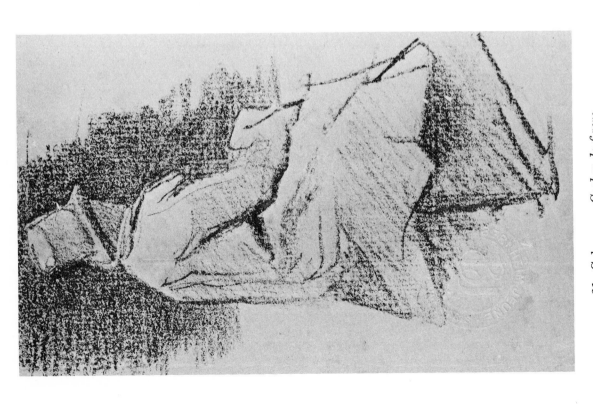

21. Cabman · *Cocher de fiacre*

22. Soldier with a campstool · *Troupier au pliant*

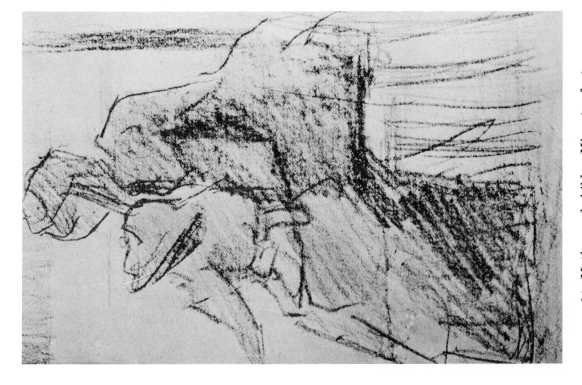

24. Mother and child · *Mère et enfant*

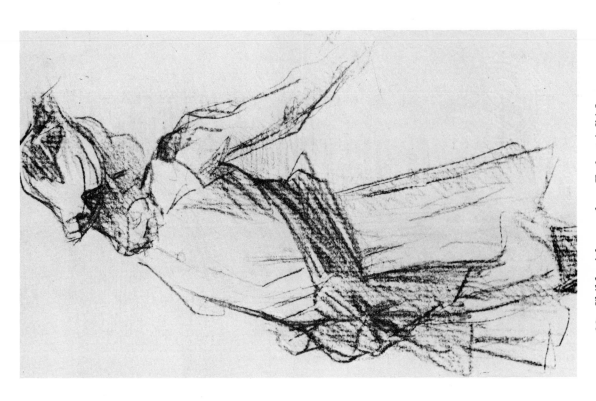

23. Child with a sash · *Enfant à l'écharpe*

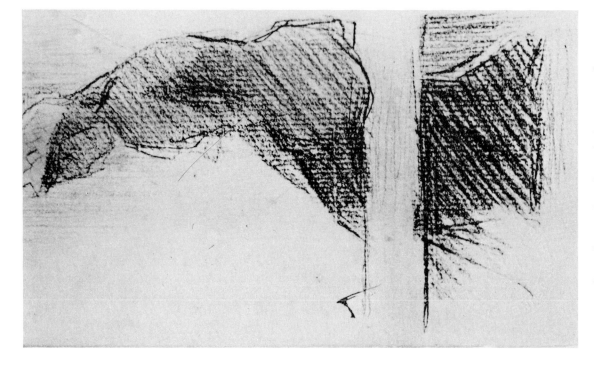

26. Seated on a bench · *Assise sur un banc*

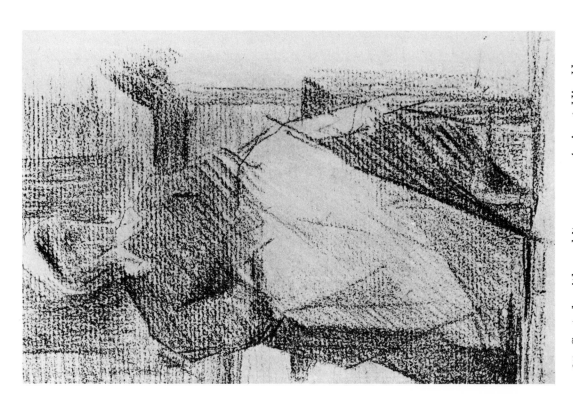

25. Seated, with a white apron · *Assise, tablier blanc*

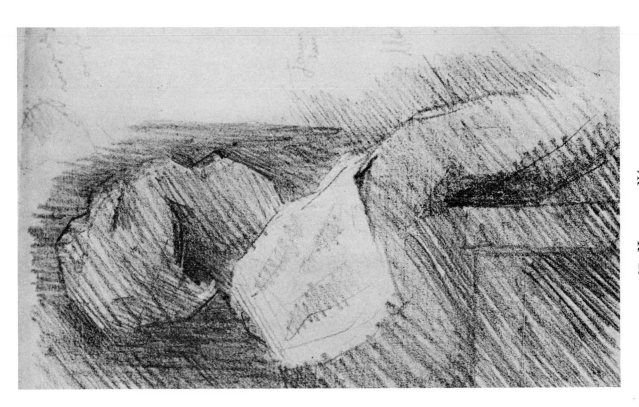

28. Woman sewing · *Couseuse*

27. Negress · *Négresse*

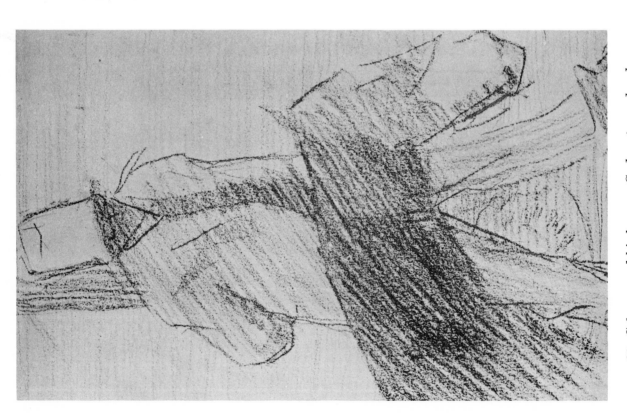

30. Seated woman · *Femme assise*

29. Cabman and his horse · *Cocher et son cheval*

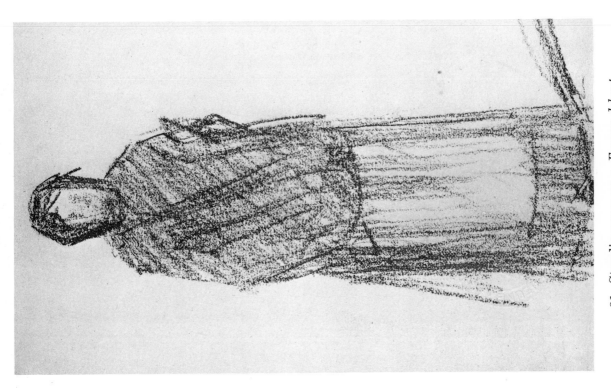

31. Standing woman · *Femme debout*

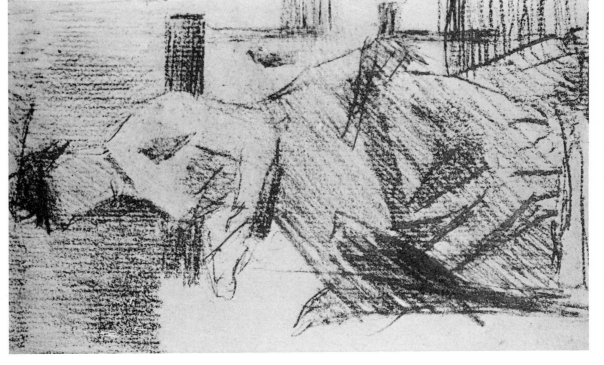

32. Woman on a bench · *Femme sur un banc*

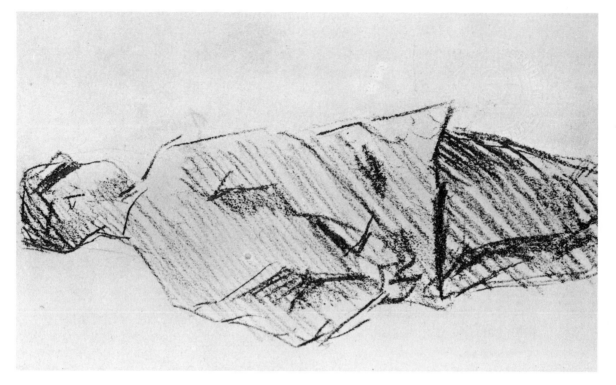

34. Groom · *Groom*

33. Couple · *Couple*

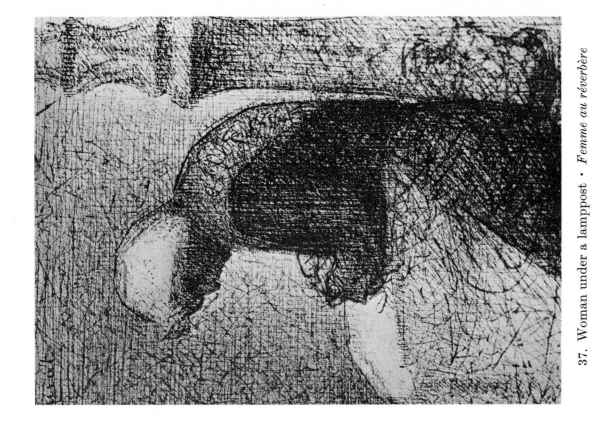

37. Woman under a lamppost · *Femme au réverbère*

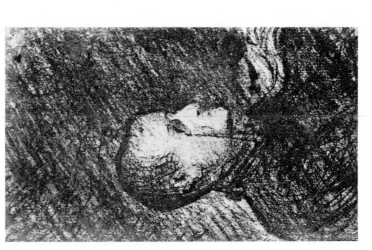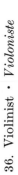

36. Violinist · *Violoniste*

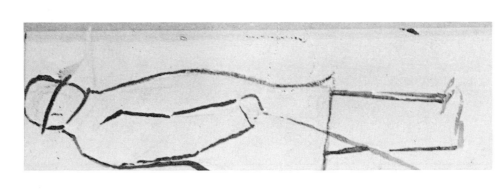

35. Funny figure of a man · *Un bonhomme*

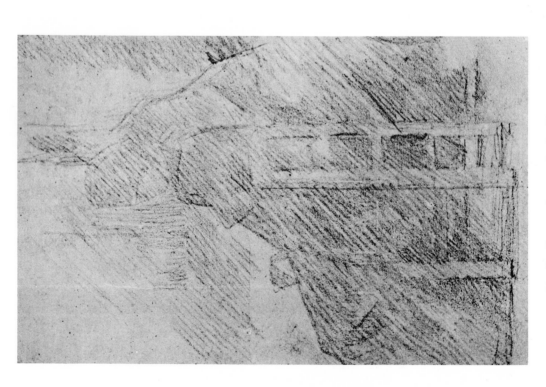

39. In shirtsleeves · *En bras de chemise*

38. In the garden · *Au jardin*

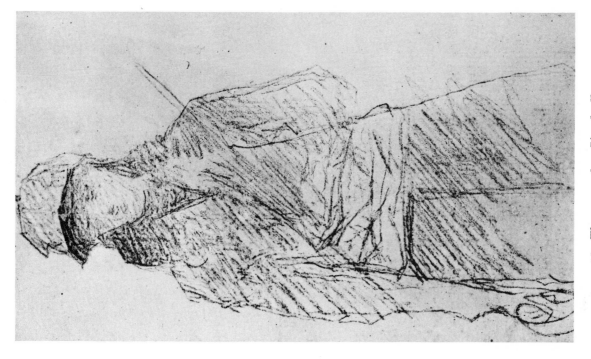

41. The parasol · *L'ombrelle*

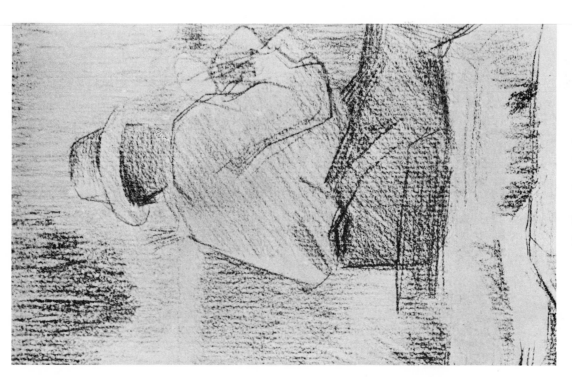

40. Seated · *Assis*

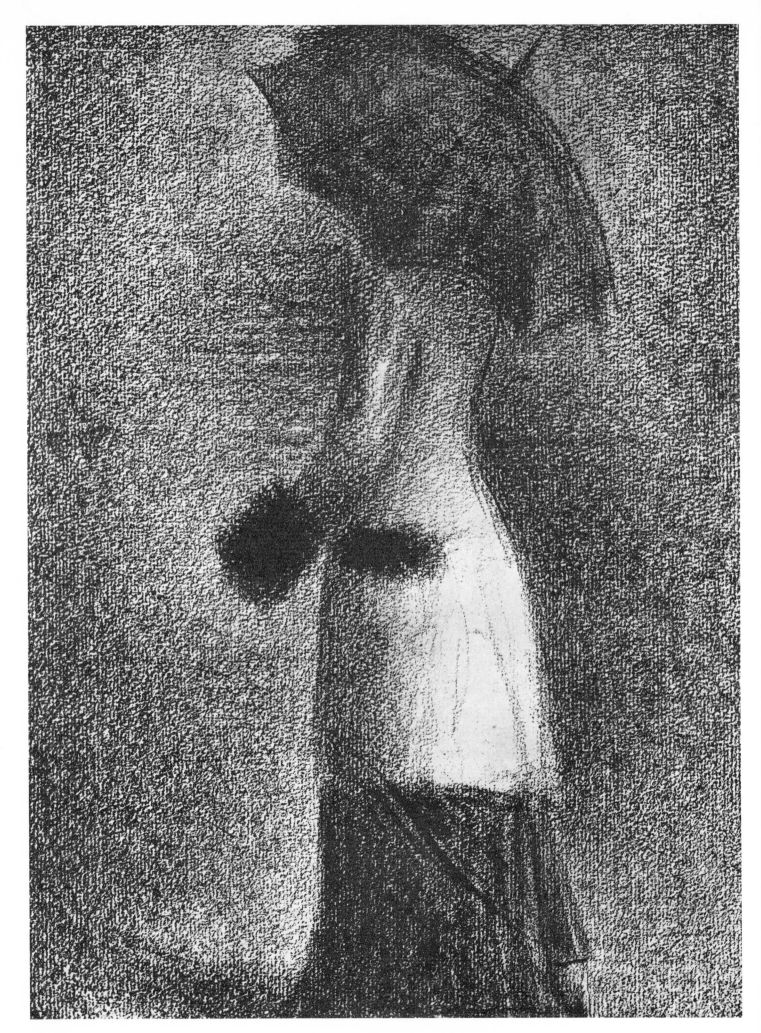

42. The white coat · *Le manteau blanc*

43. The haystacks · *Les meules*

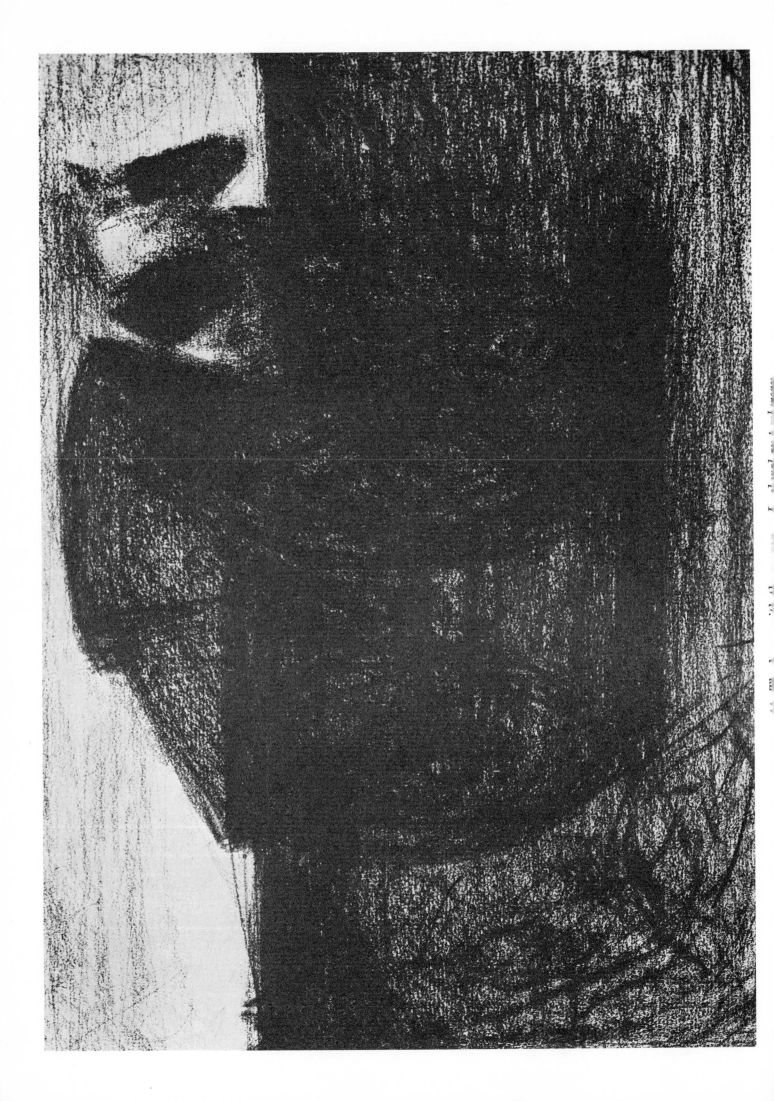

45. The two carts · *Les deux charrettes*

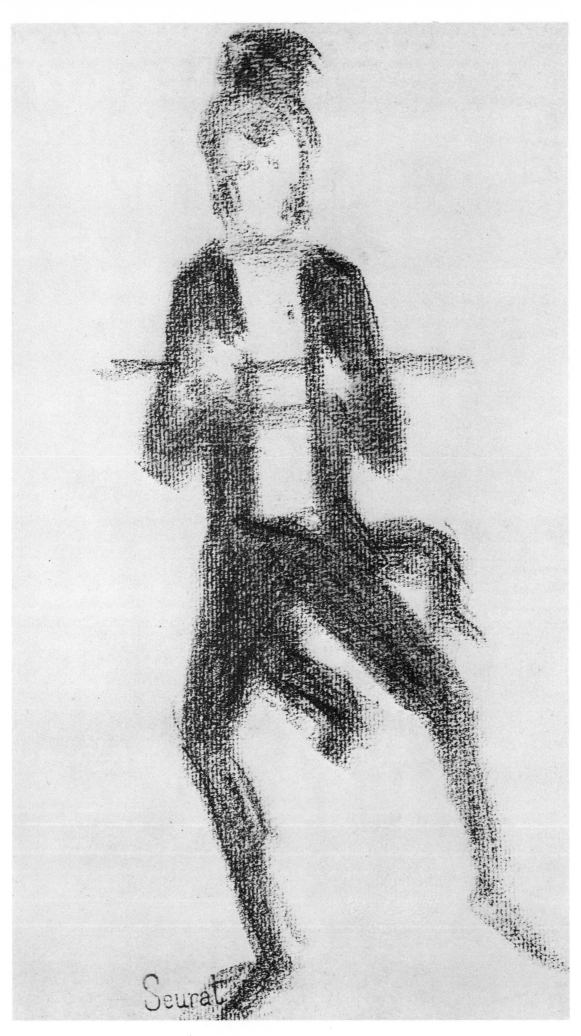

46. Dancer with a cane · *Le danseur à la canne*

47. Plowing · *Le labourage*

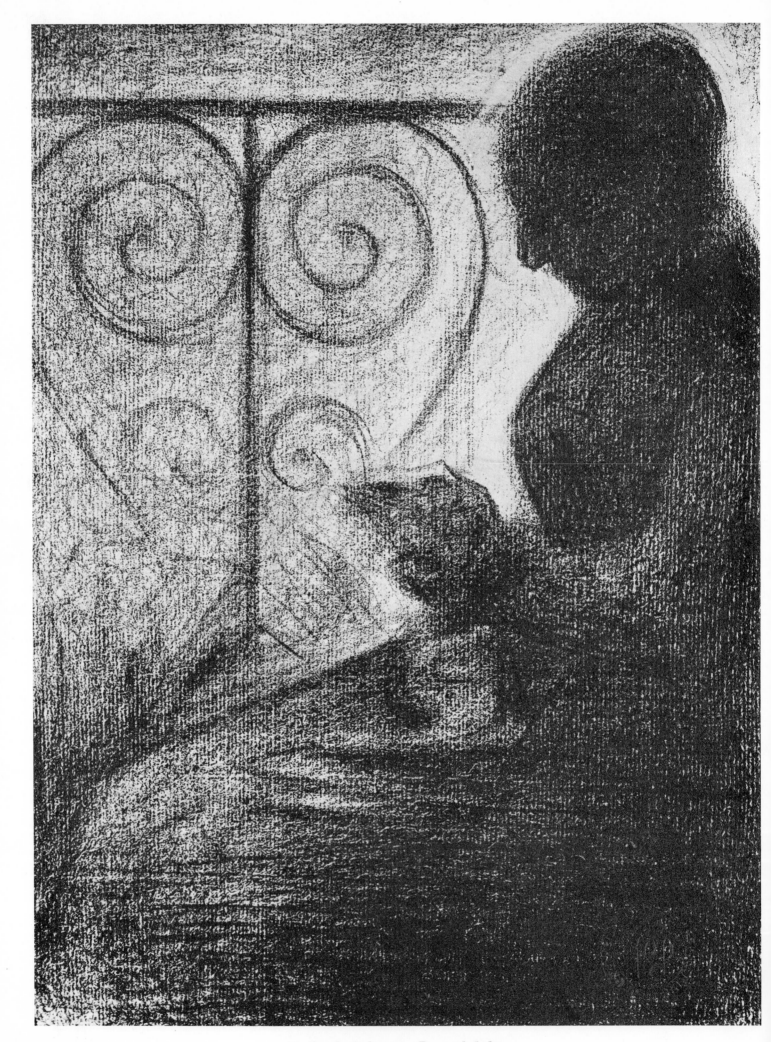

48. On the balcony · *Devant le balcon*

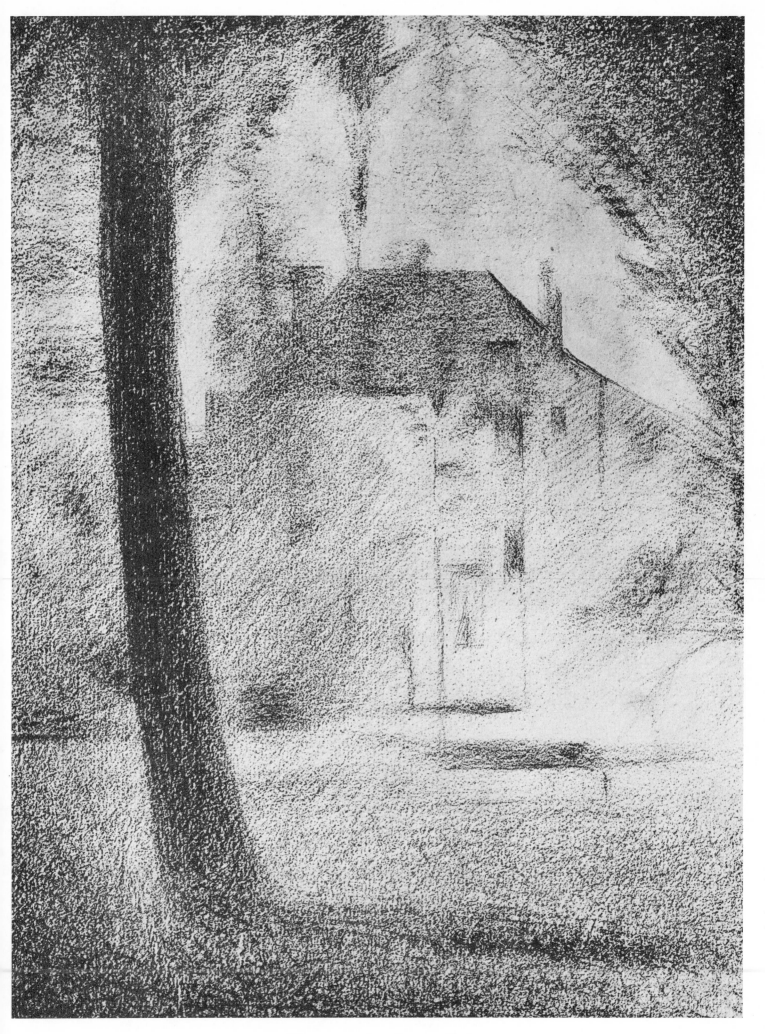

49. The tree trunk · *Le tronc d'arbre*

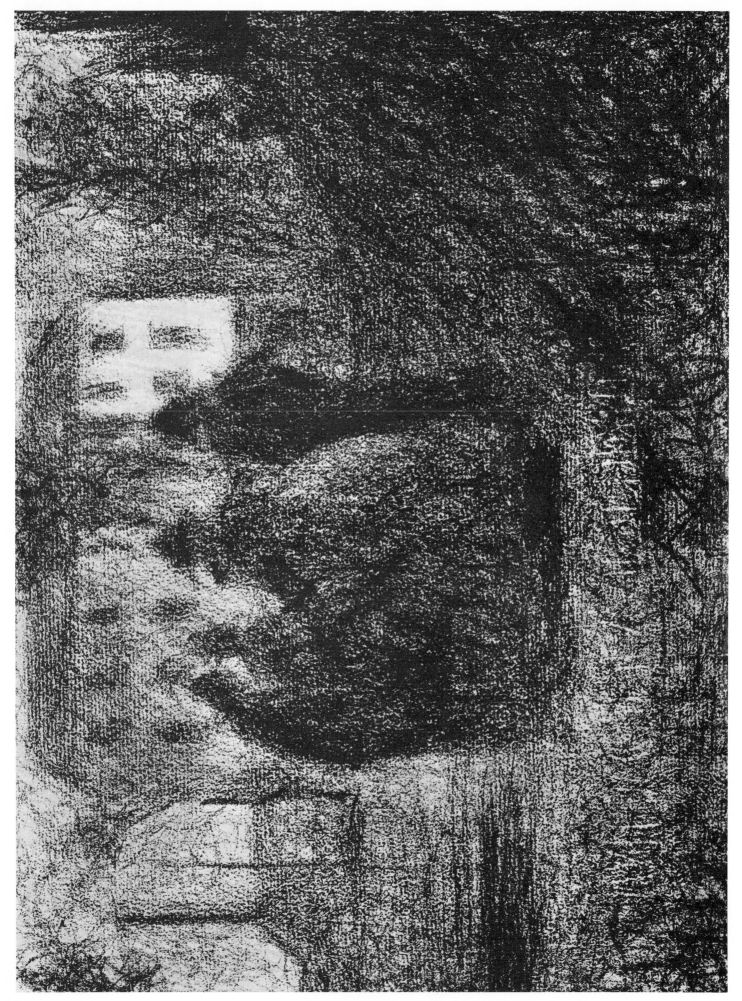

50. Group of people · *Groupe de gens*

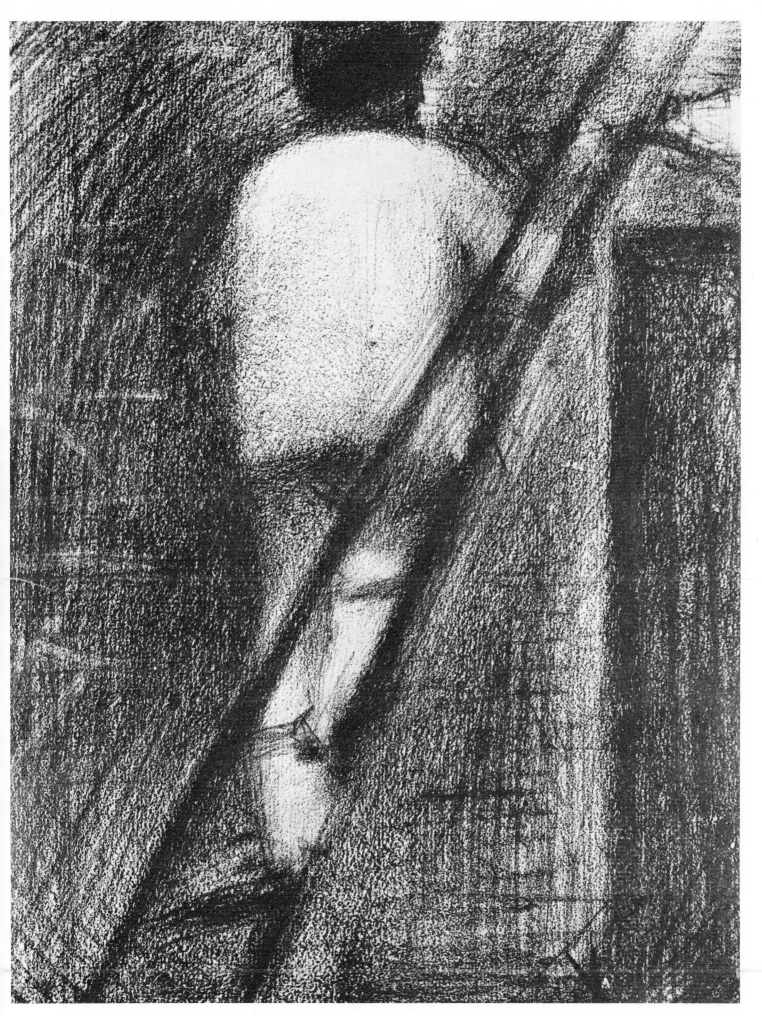

51. Man whitewashing · *Le badigeonneur*

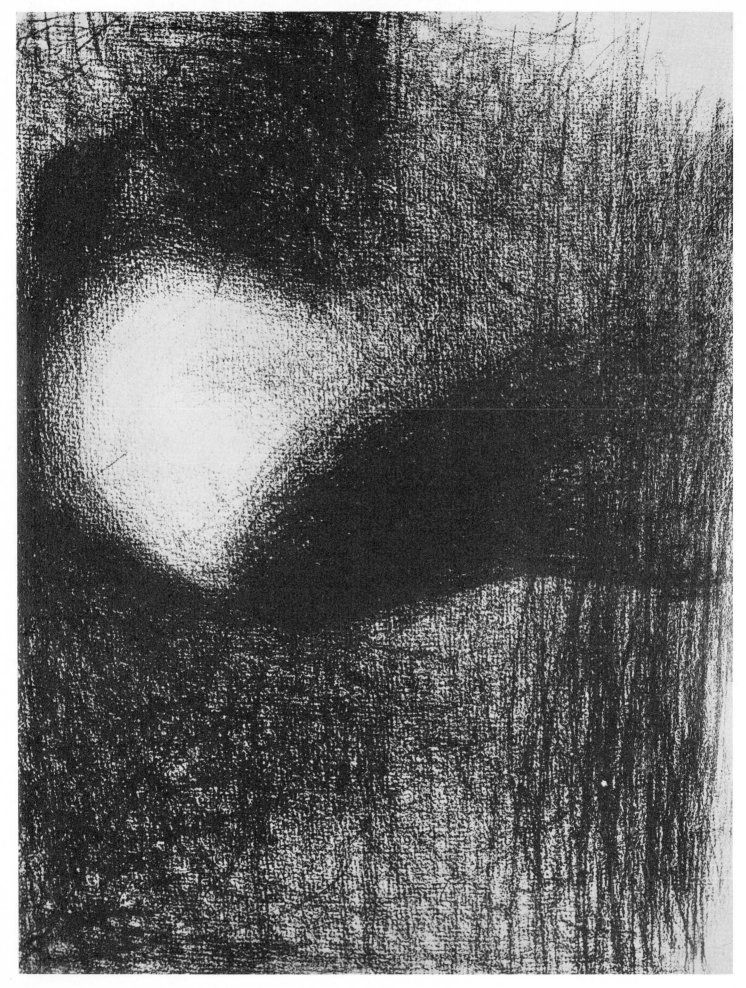

52. Working the soil · *Au travail de la terre*

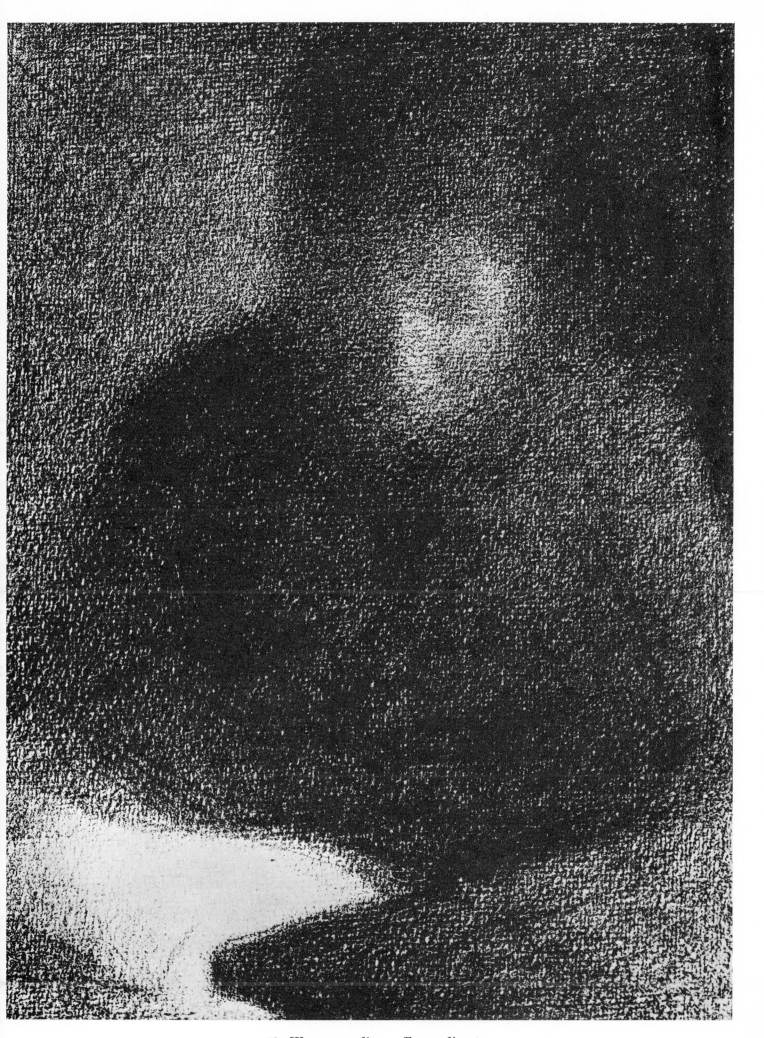

53. Woman reading · *Femme lisant*

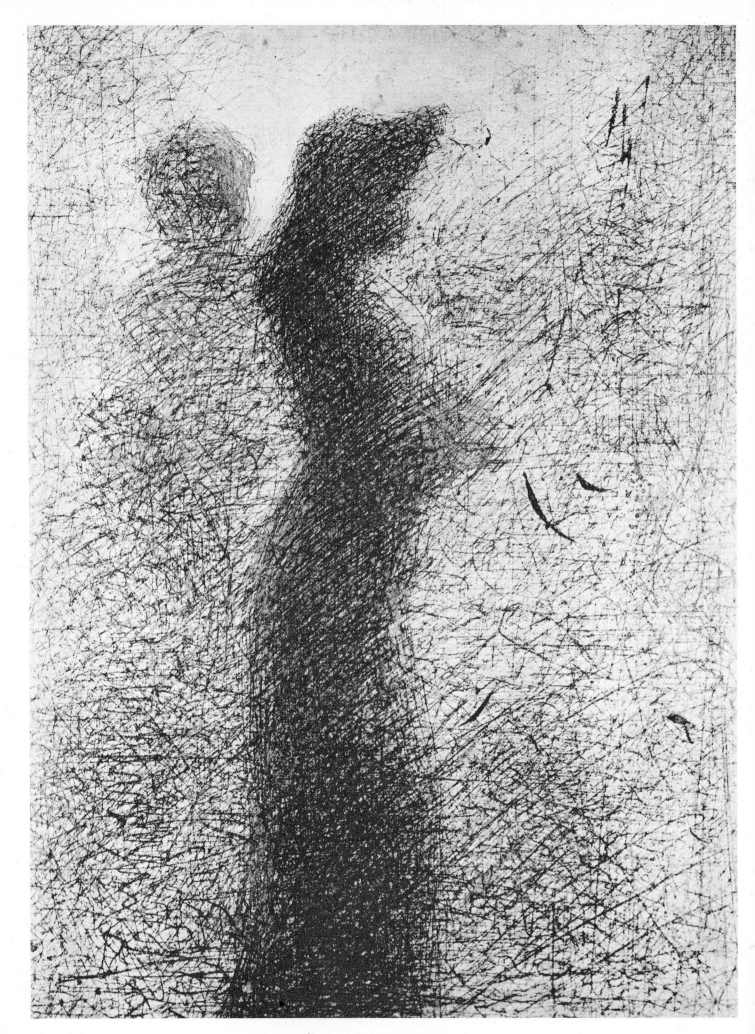

54. The lady in black · *La dame en noir*

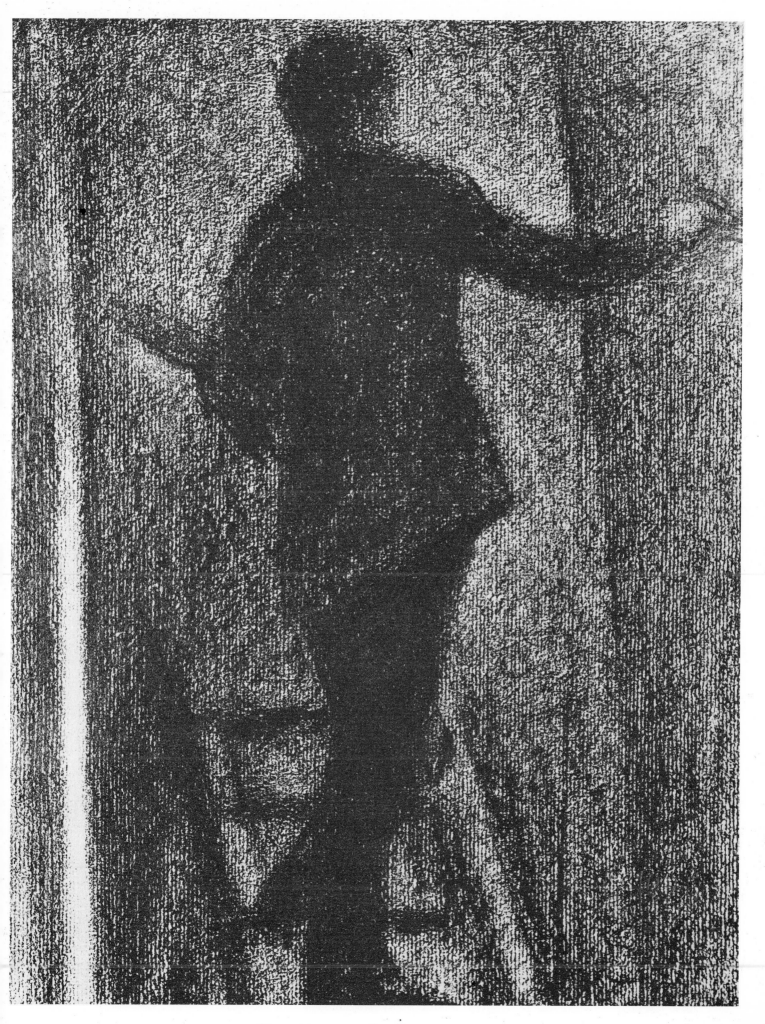

55. The painter at work · *Le peintre au travail*

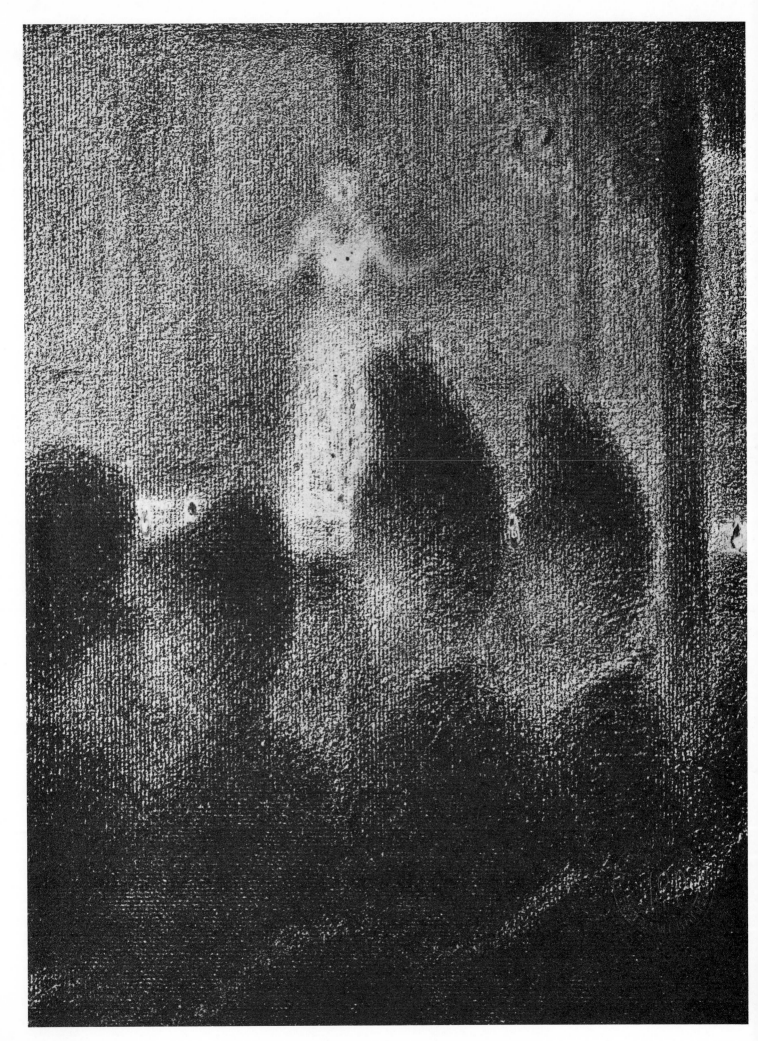

56. At the "Concert Européen" · *Au Concert Européen*

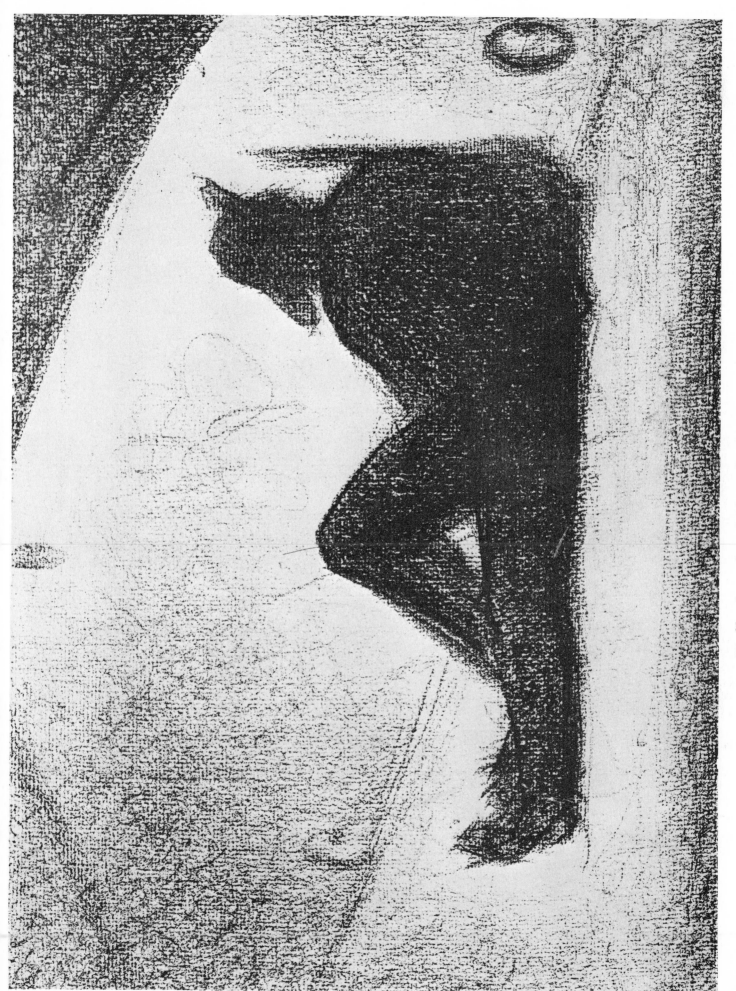

57. Sleeping under a bridge · *Couché sous un pont*

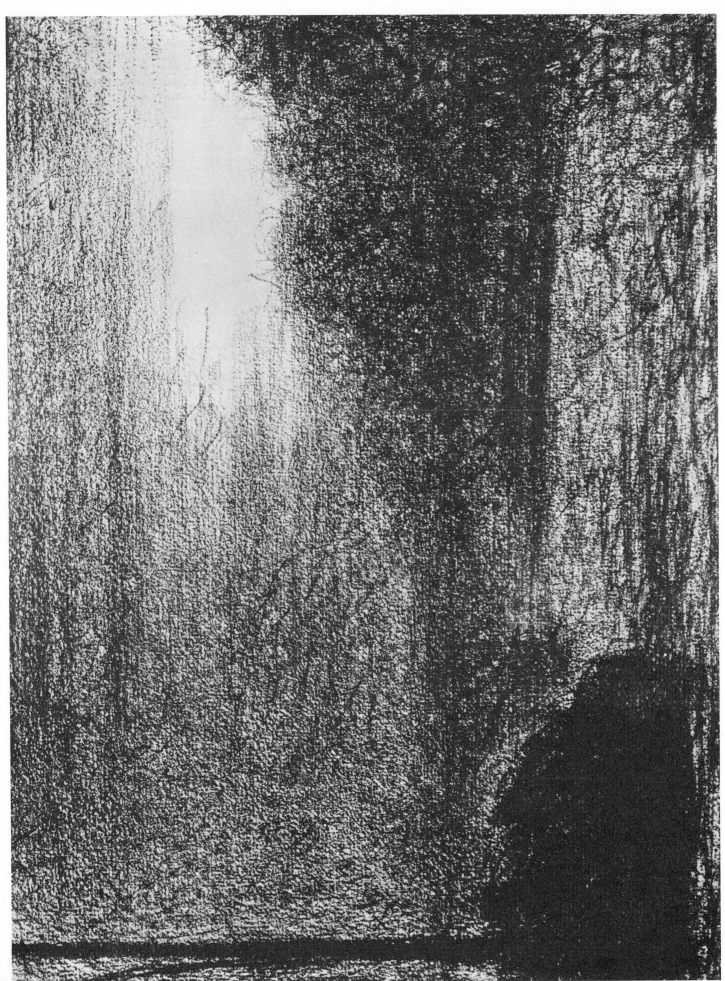

58 · The barge · La péniche

59. The ragpicker · *Le chiffonnier*

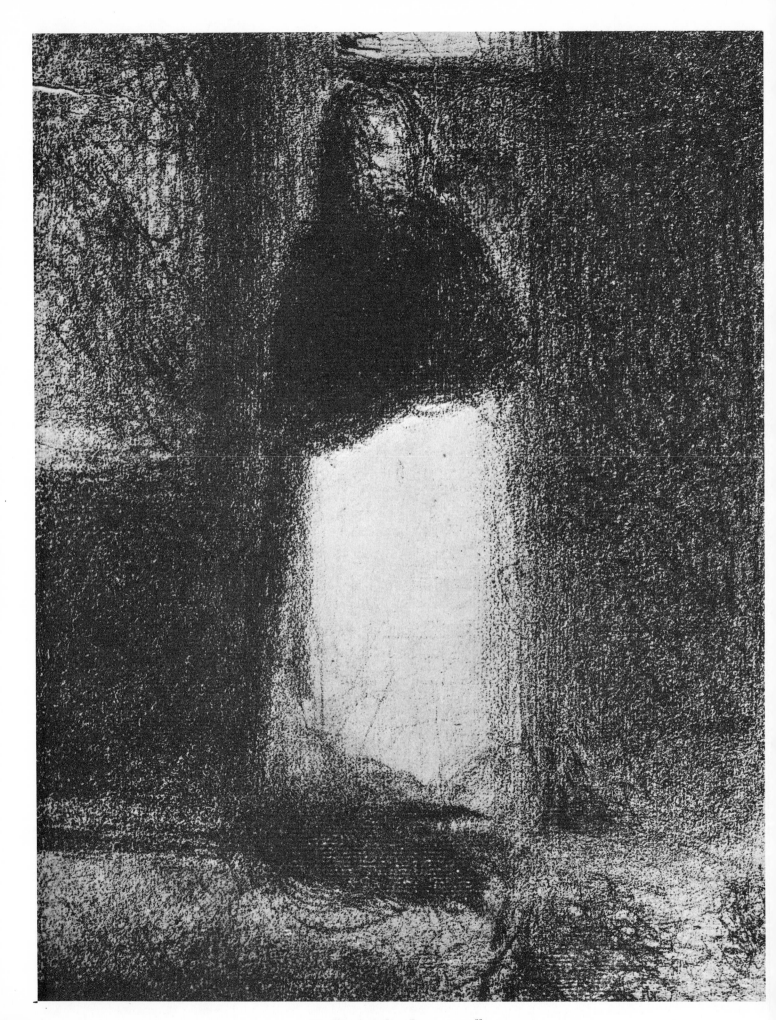

60. The bawd · *La maquerelle*

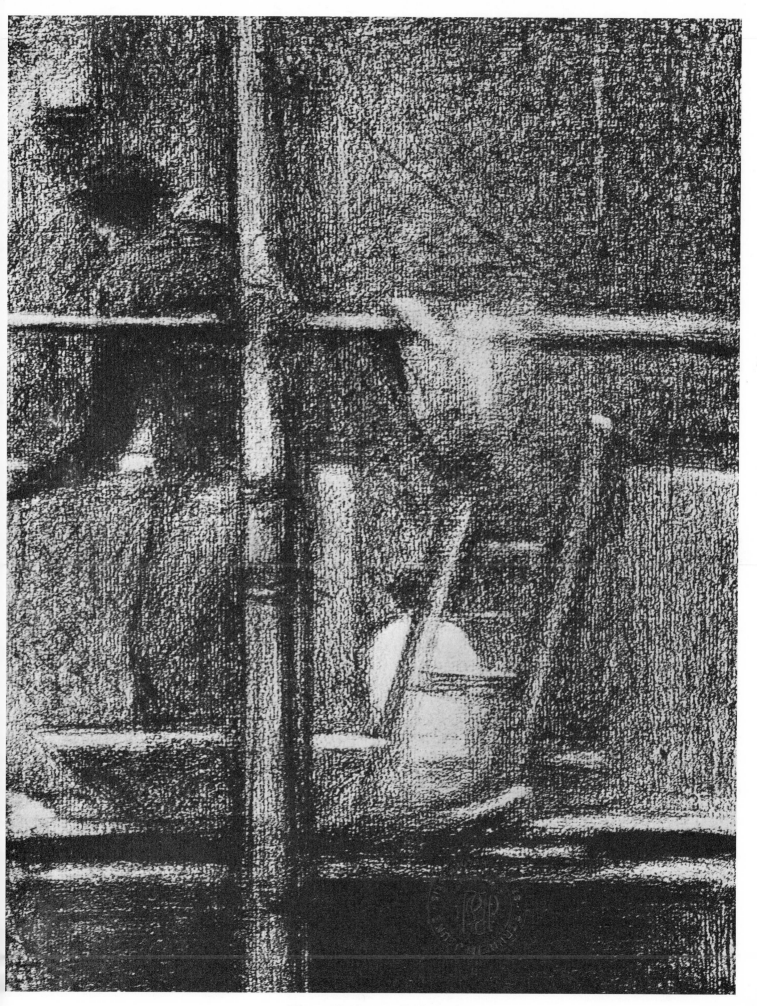

61. The scaffolding · *L'échafaudage*

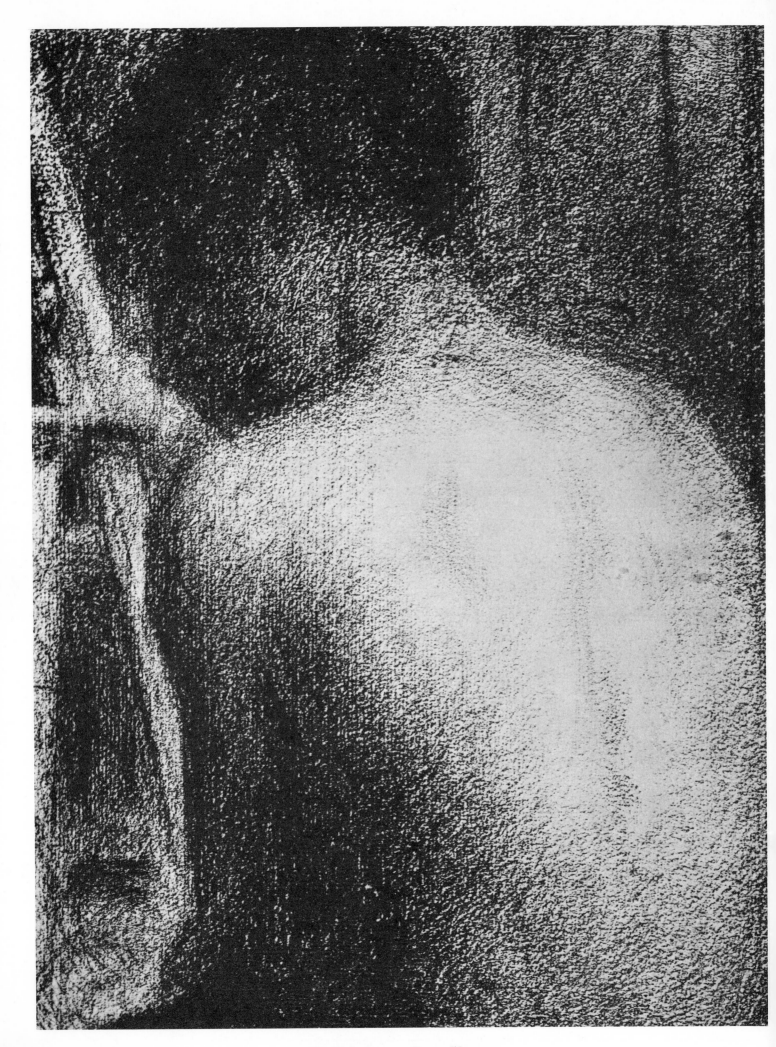

62. Male torso · *Torse d'homme*

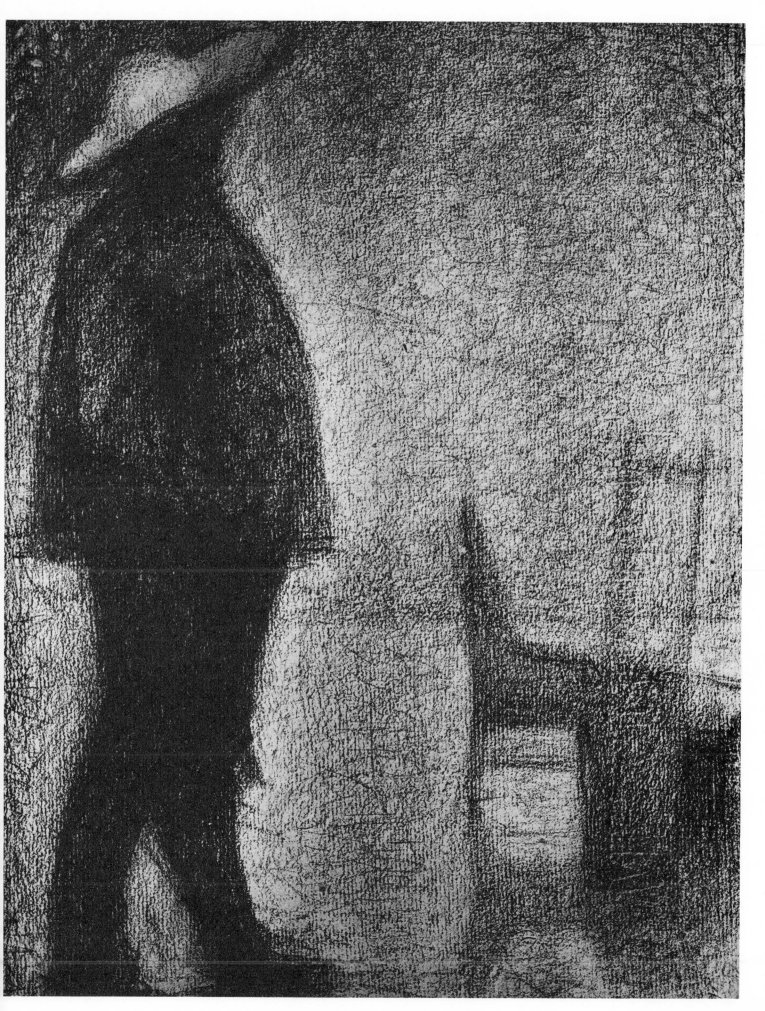

63. Market porter · *Fort de la halle*

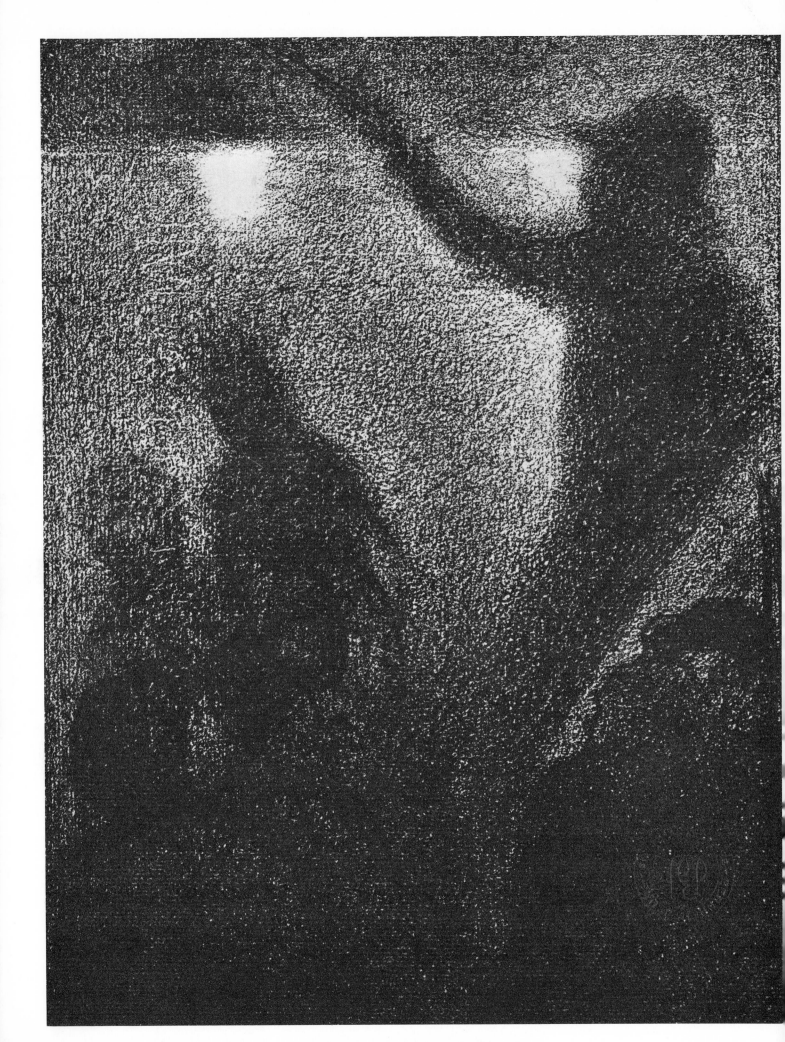

64. The street performers · *Les banquistes*

65. Traveling performers · *Saltimbanques*

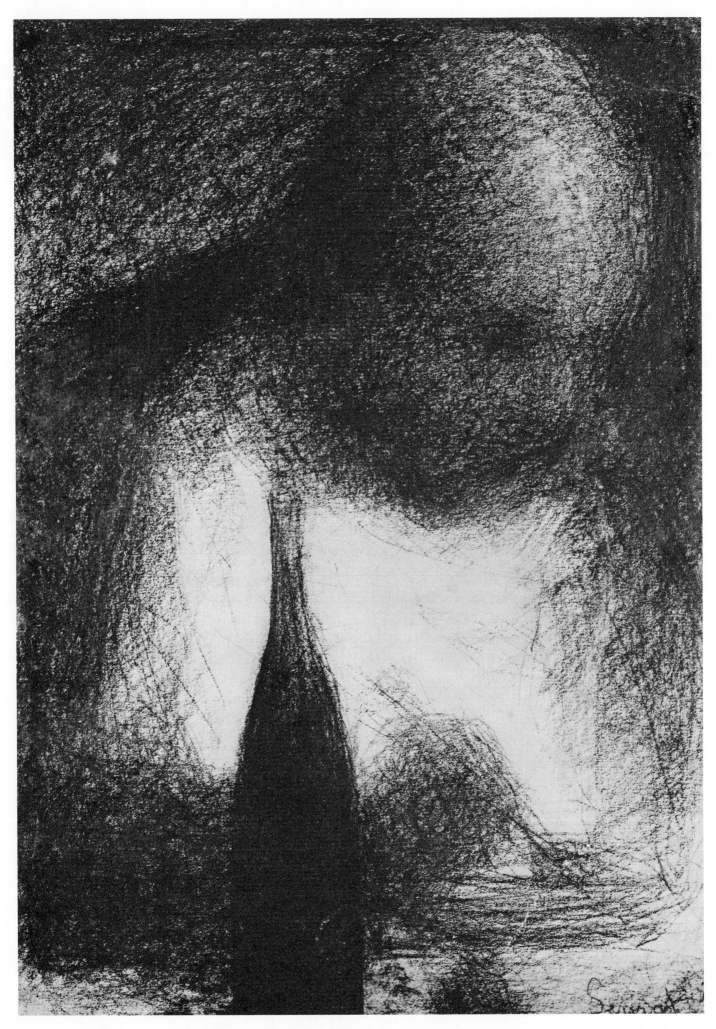

66. Man dining (the artist's father) · *Le dîneur (père de G. Seurat)*

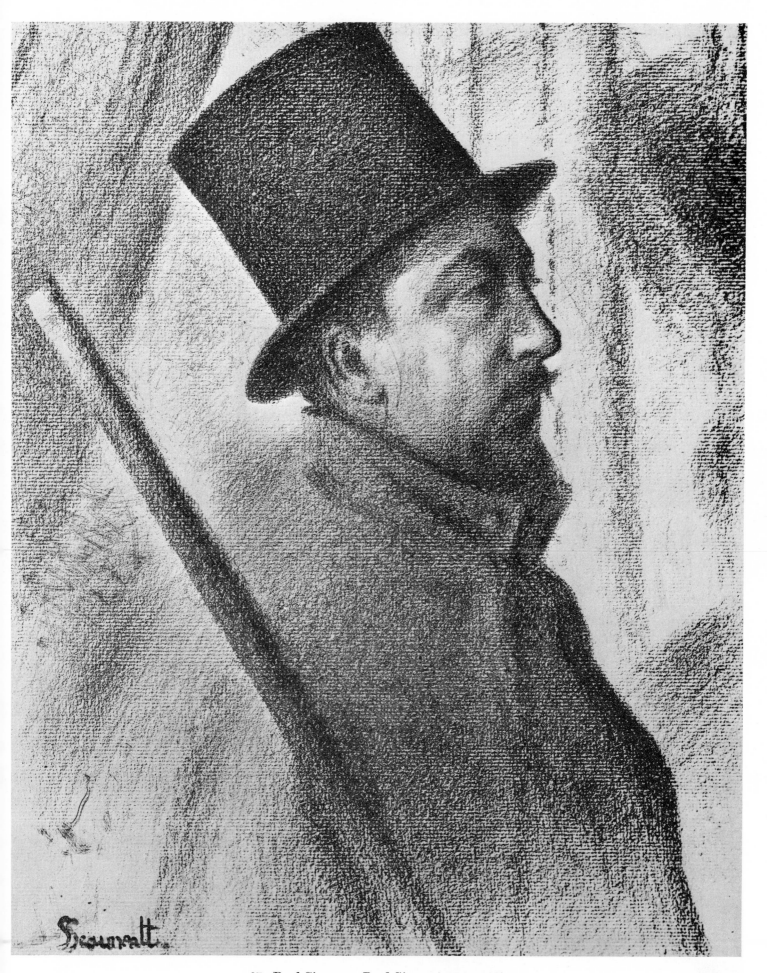

67. Paul Signac · *Paul Signac* (1889–1890)

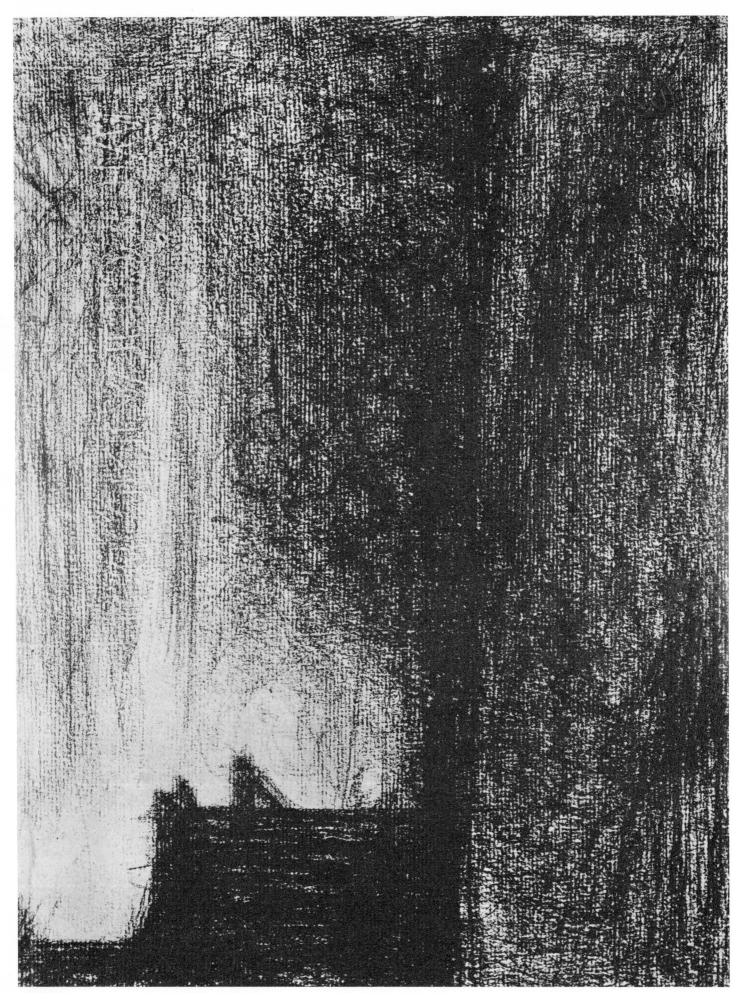

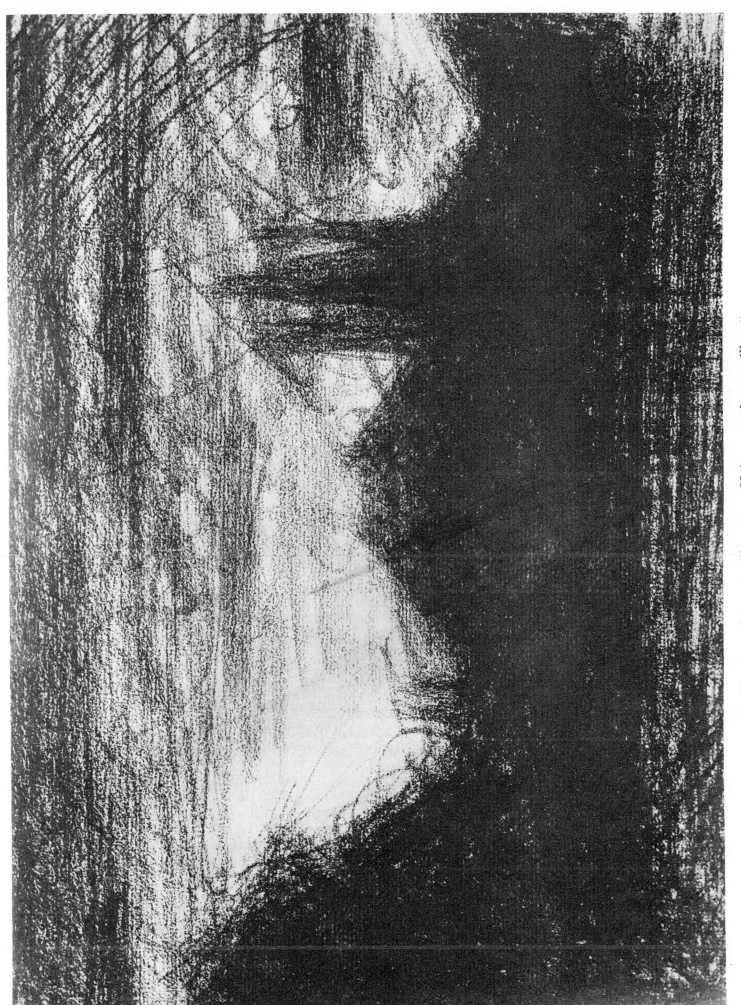

69. Houses and trees in silhouette · *Maisons et arbres en silhouette*

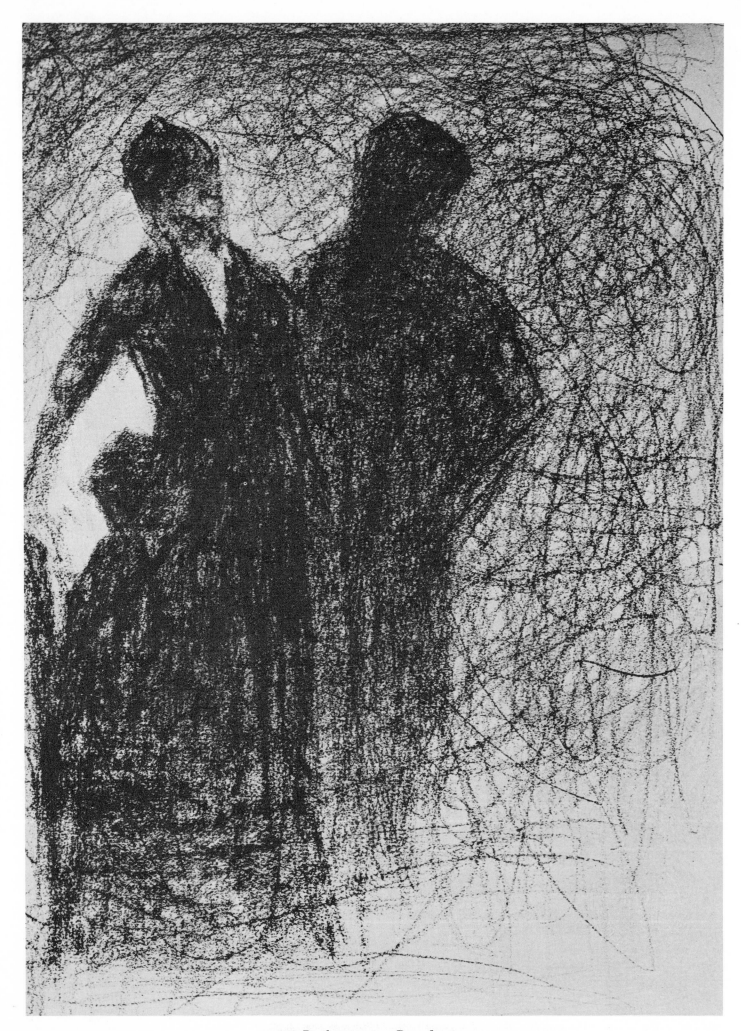

70. In the street · *Dans la rue*

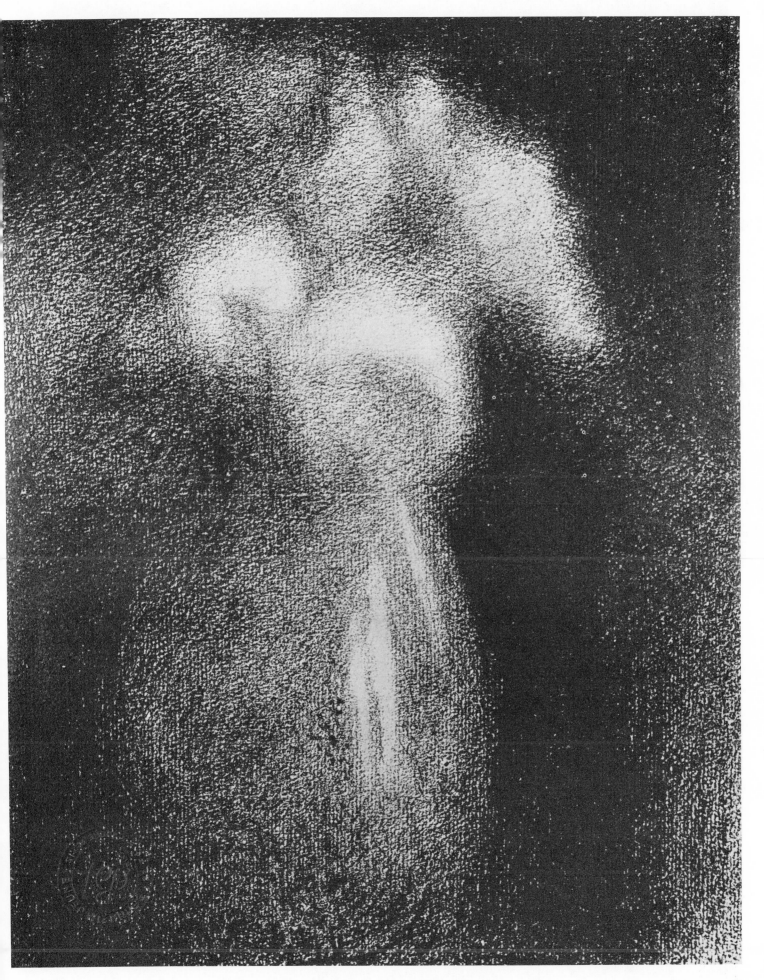

71. Roses in a vase · *Roses dans un vase*

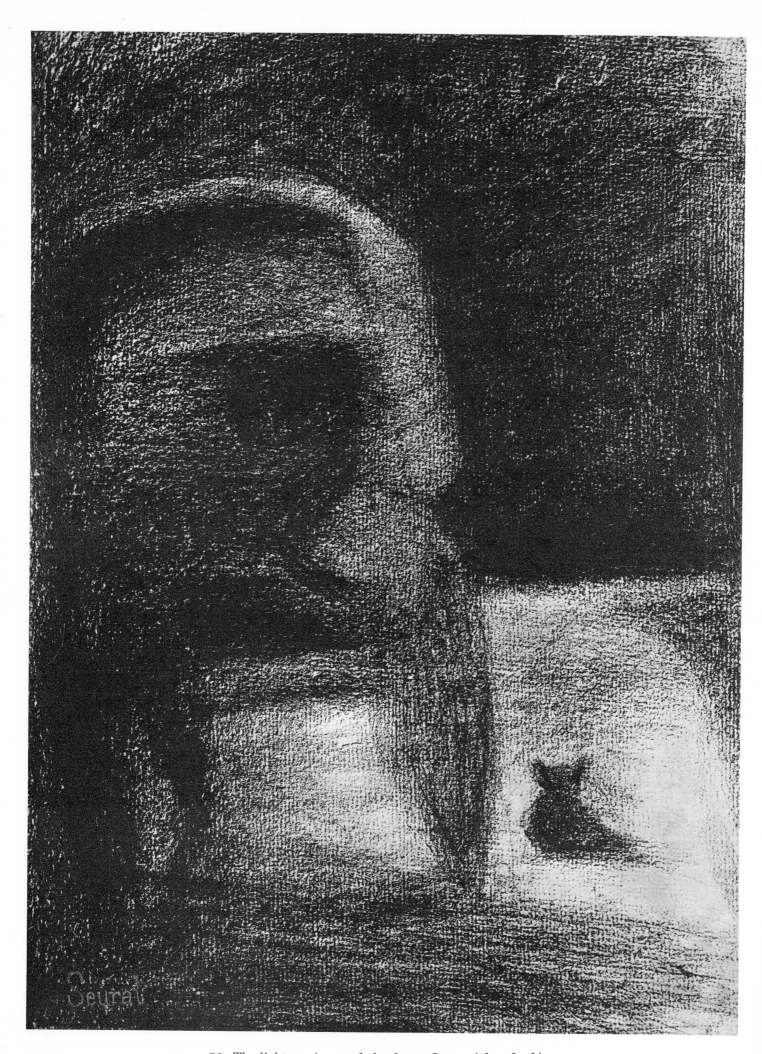

72. The light carriage and the dog · *La carriole et le chien*

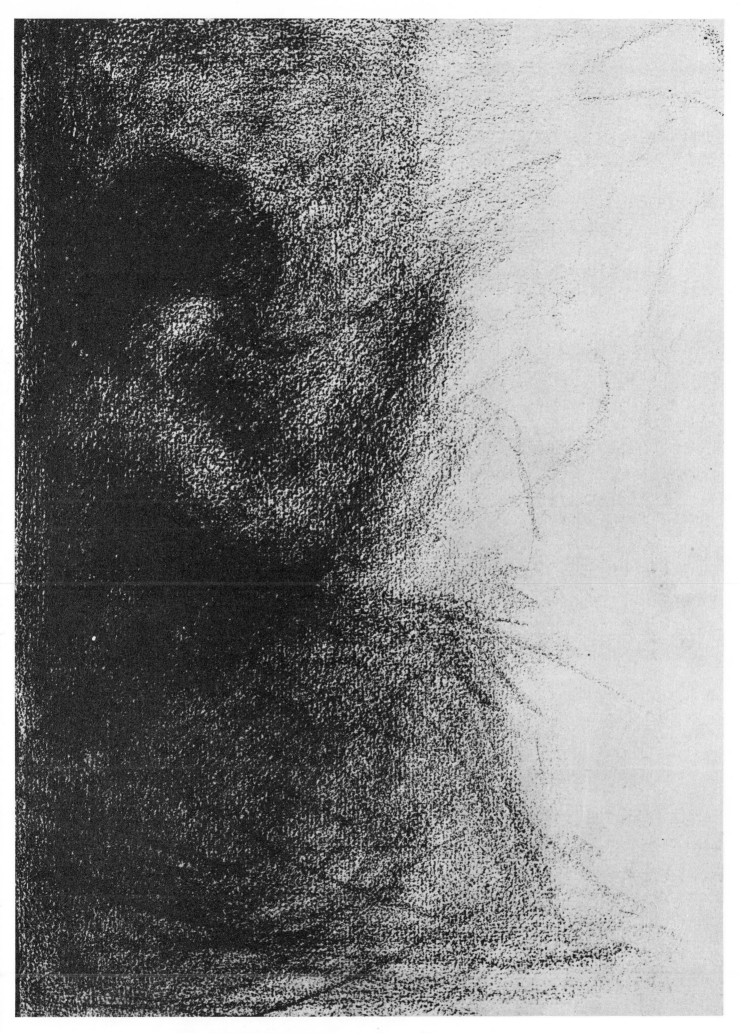

73. Woman sitting on the floor · *Femme assise bas*

74. With two horses · *A deux chevaux*

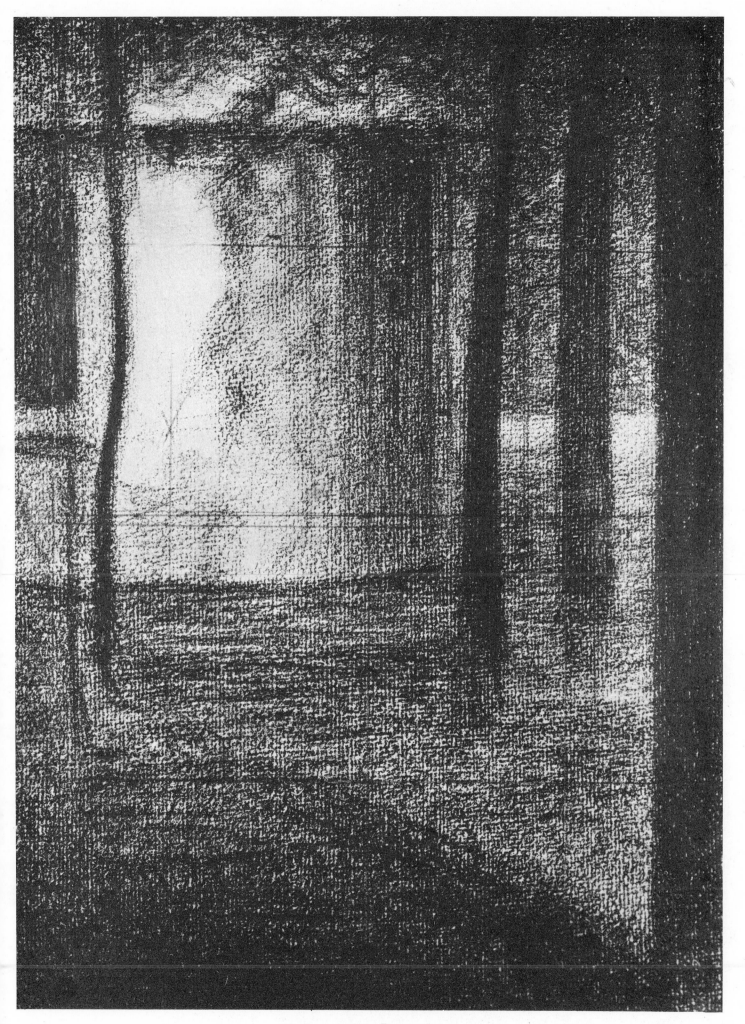

75. In a park · *Dans un parc*

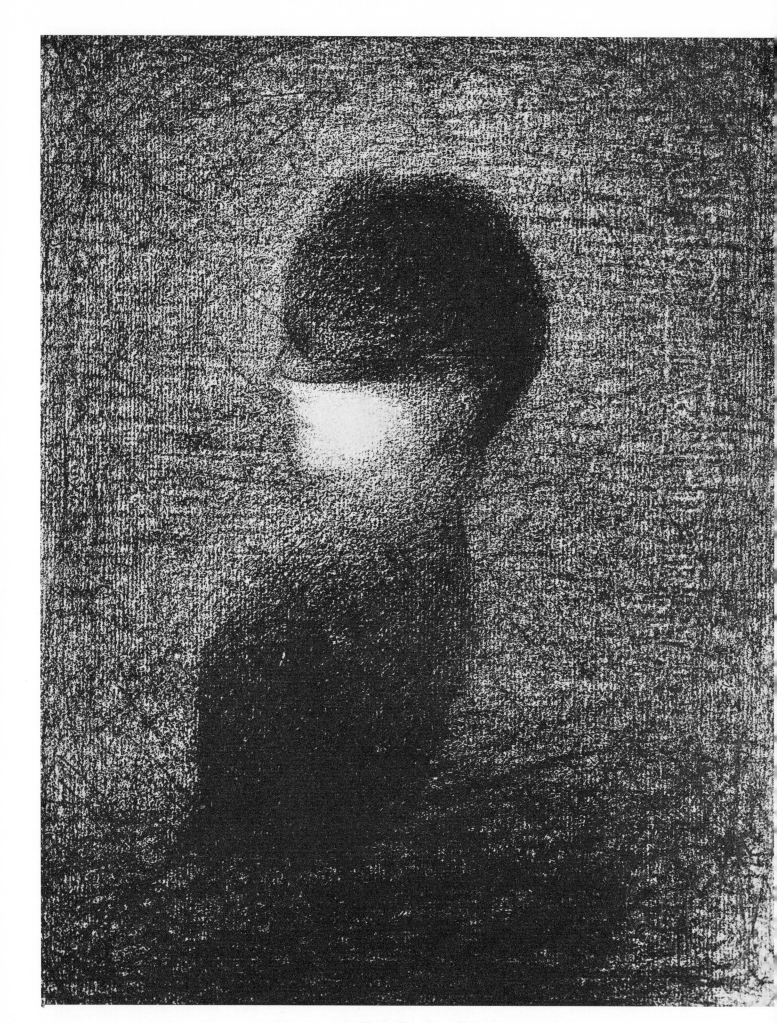

76. The veil · *La voilette*

77. The railroad tracks · *La voie ferrée*

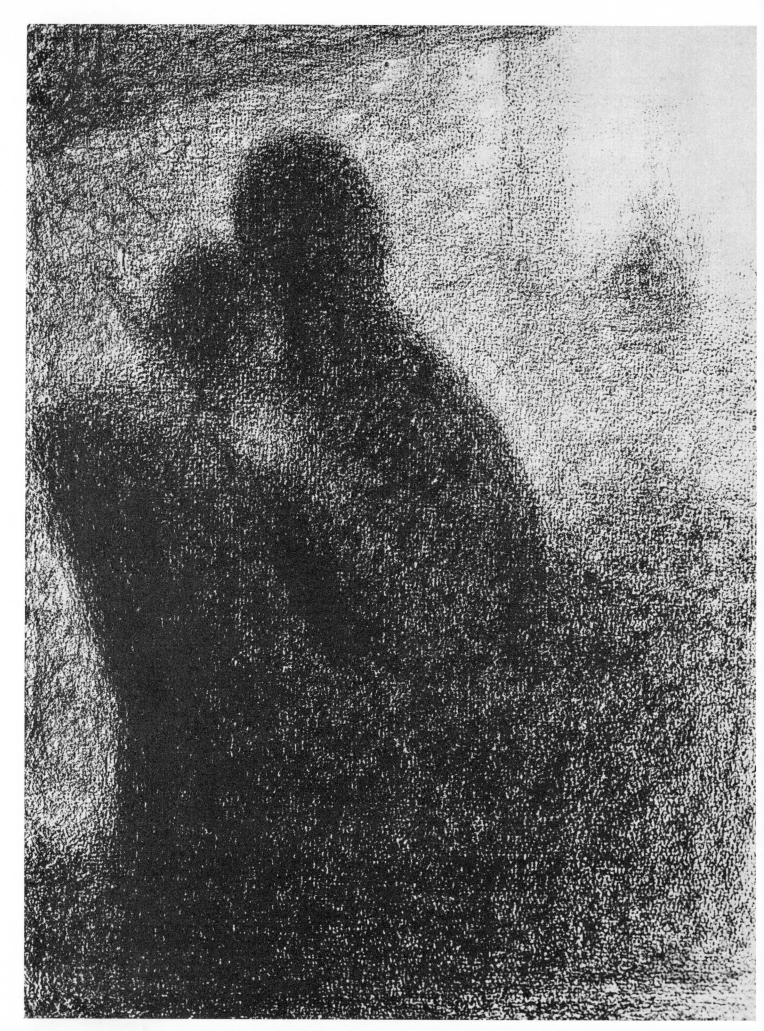

78. The armchair · *Le fauteuil*

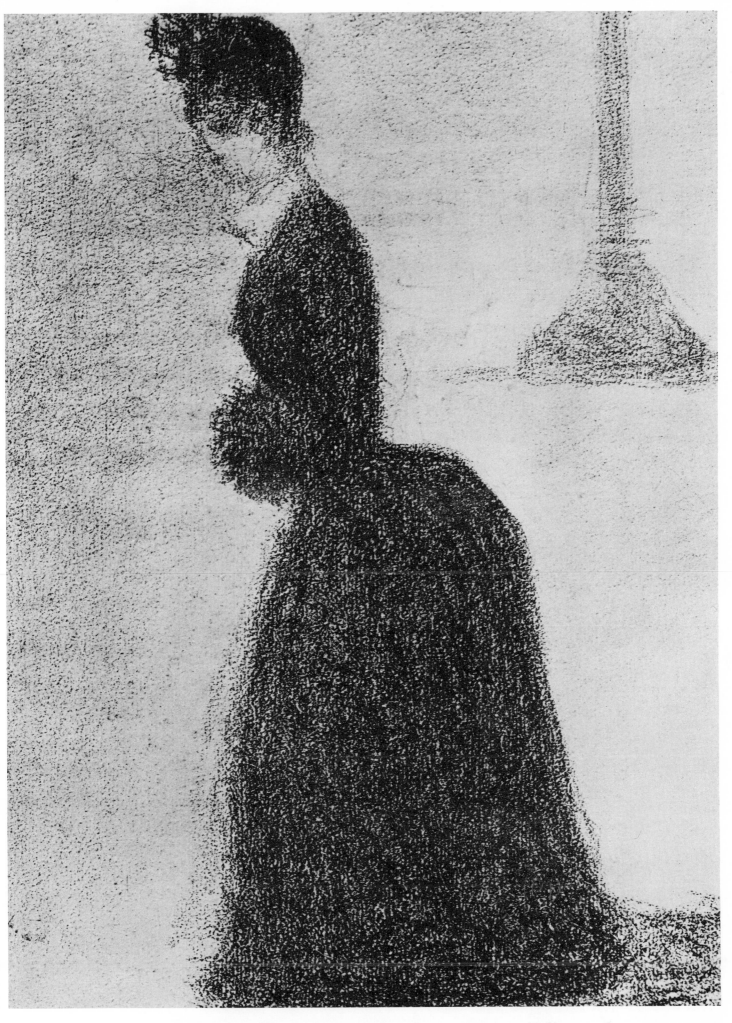

79. Woman strolling, with a lamppost · *La promeneuse au réverbère*

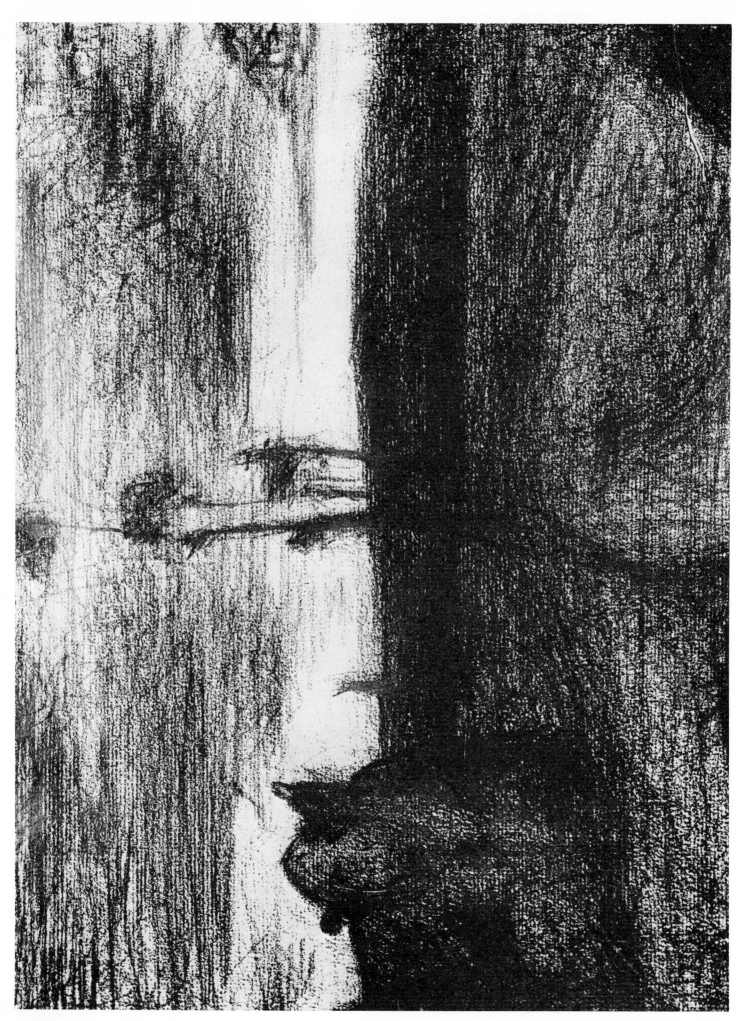

80. Slender trees · *Arbres grêles*

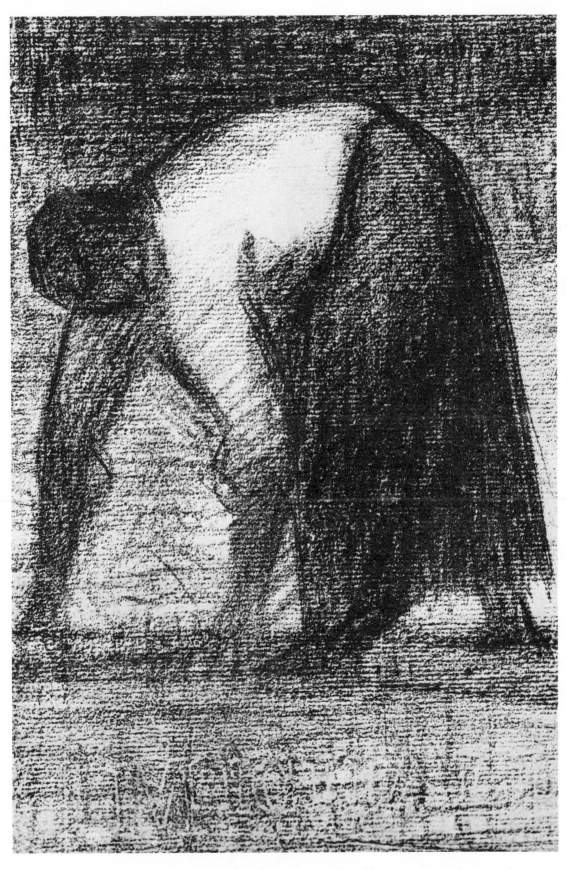

81. Peasant woman with her hands in the earth · *Paysanne les mains au sol*

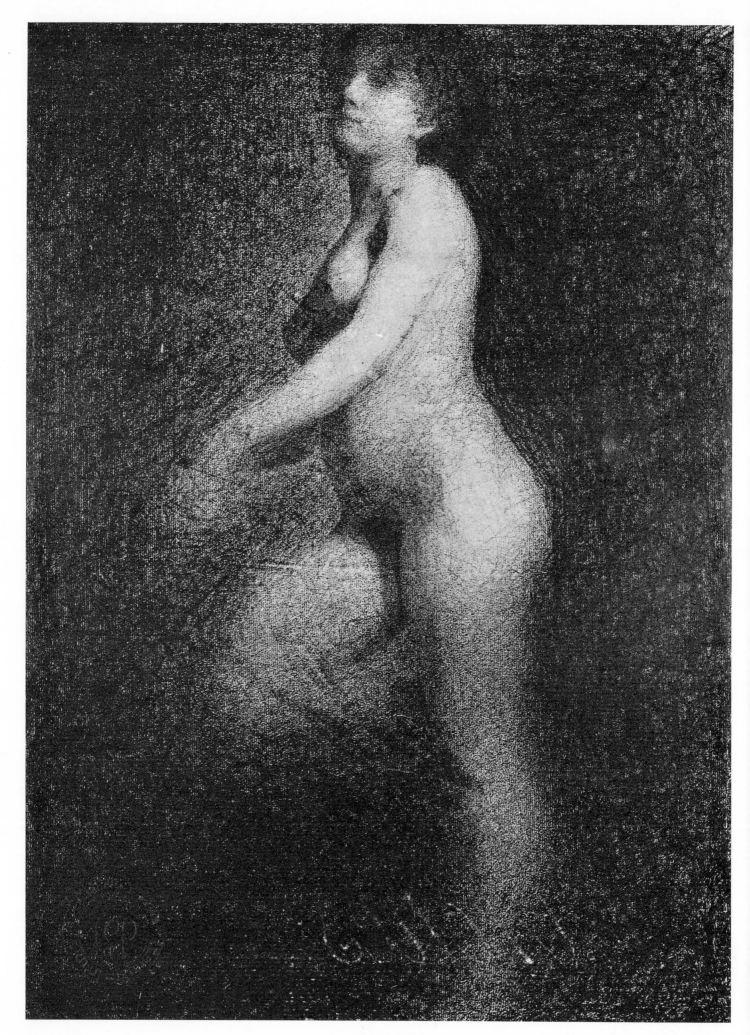

82. Nude · *Nu*

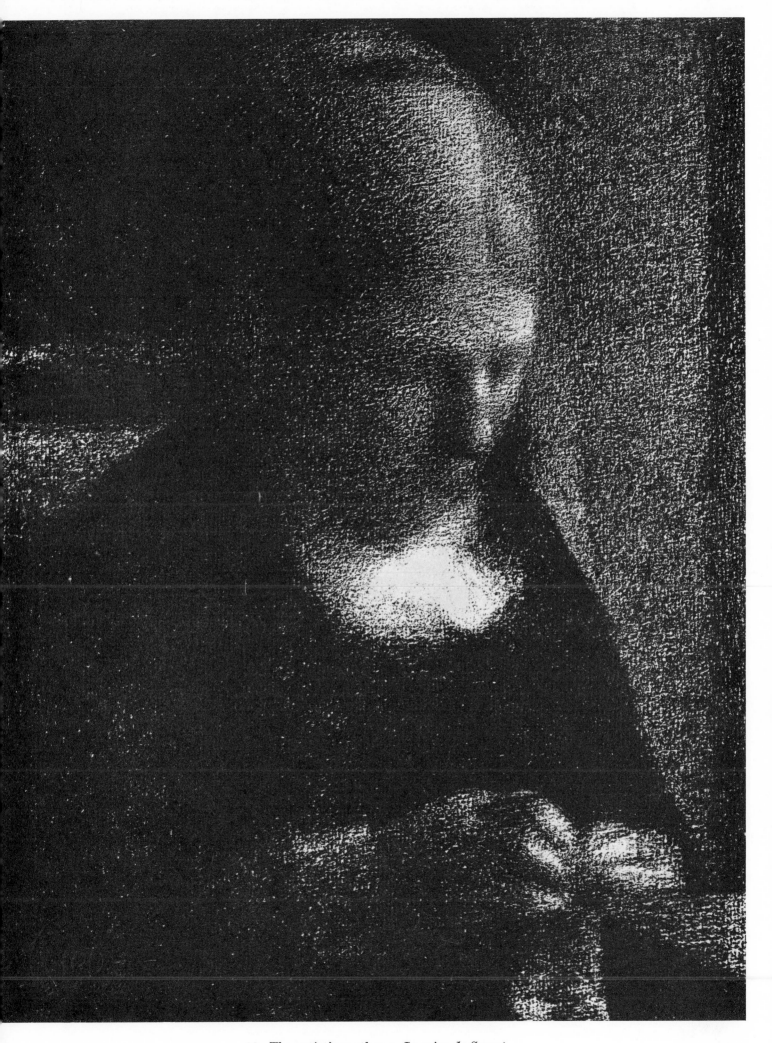

83. The artist's mother · *La mère de Seurat*

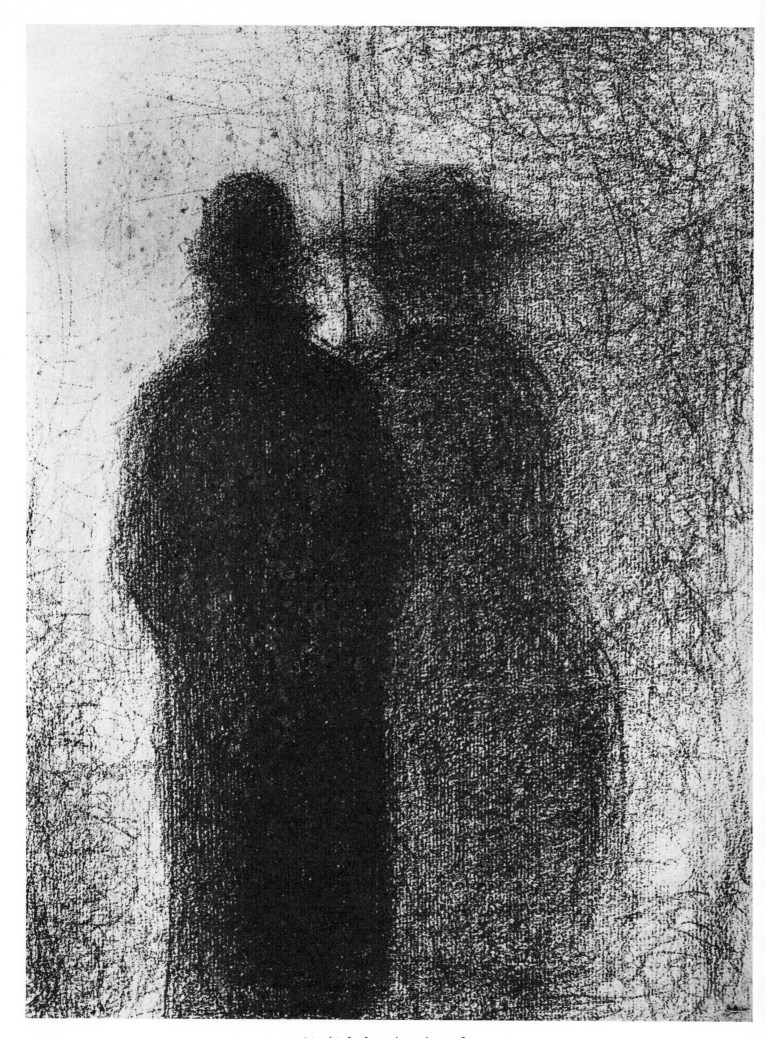

84. At dusk · *Au crépuscule*

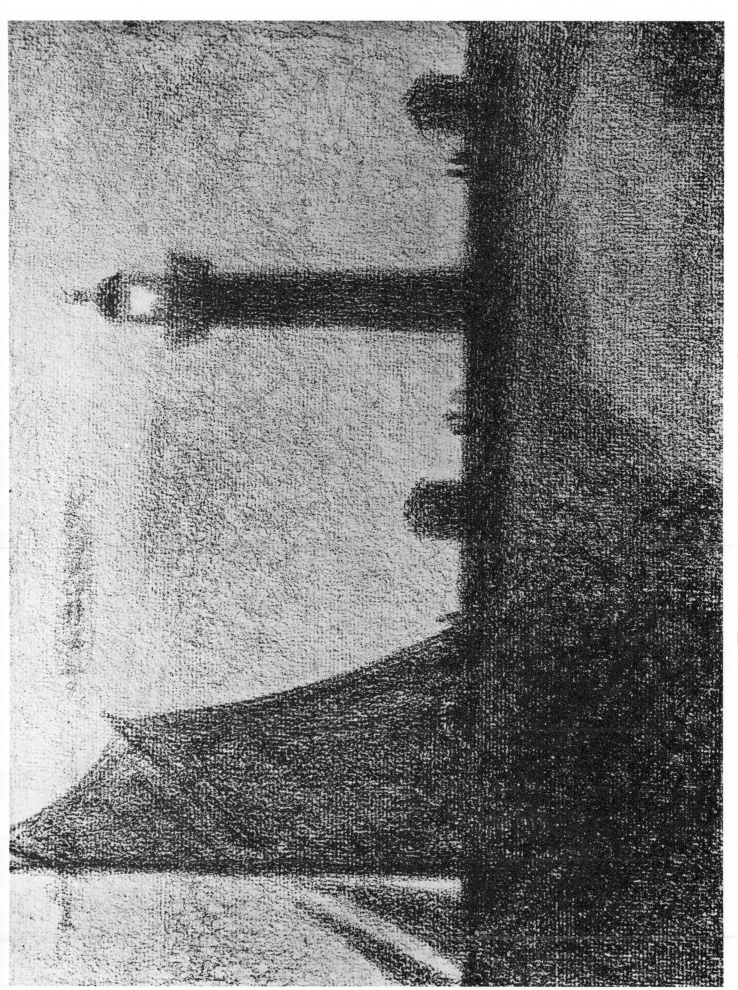

85. The lighthouse at Honfleur · *Le phare de Honfleur*

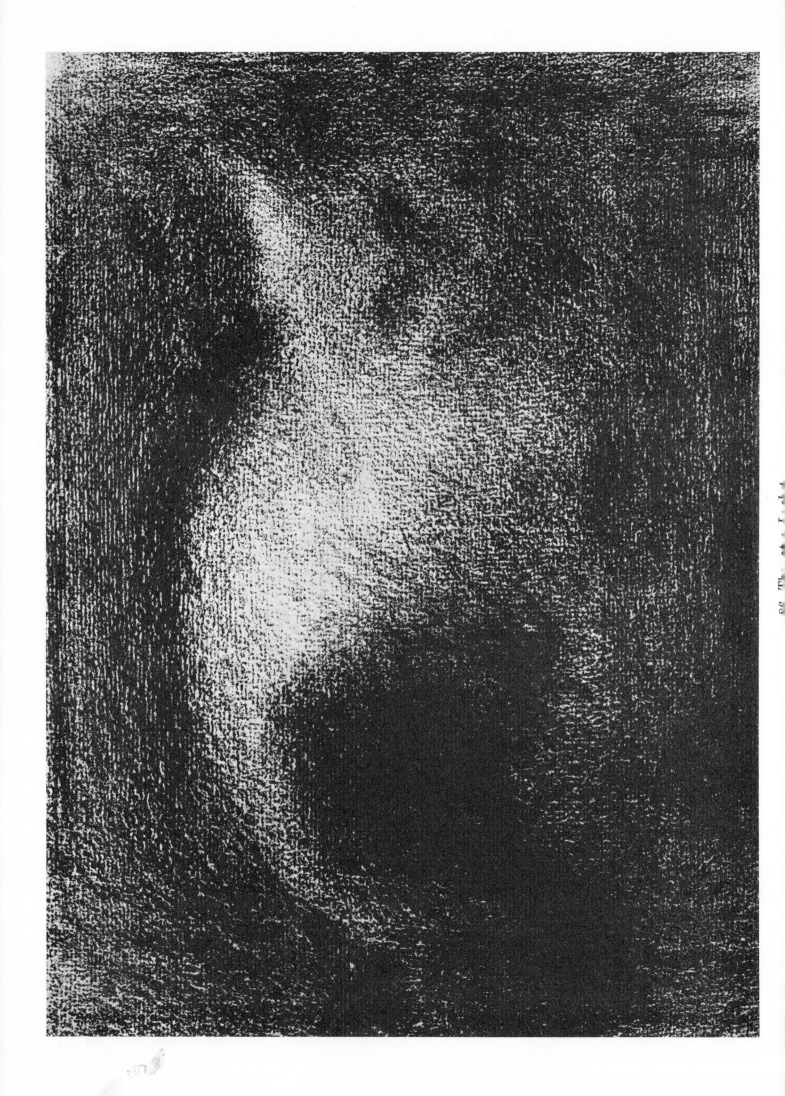

26. The state Light

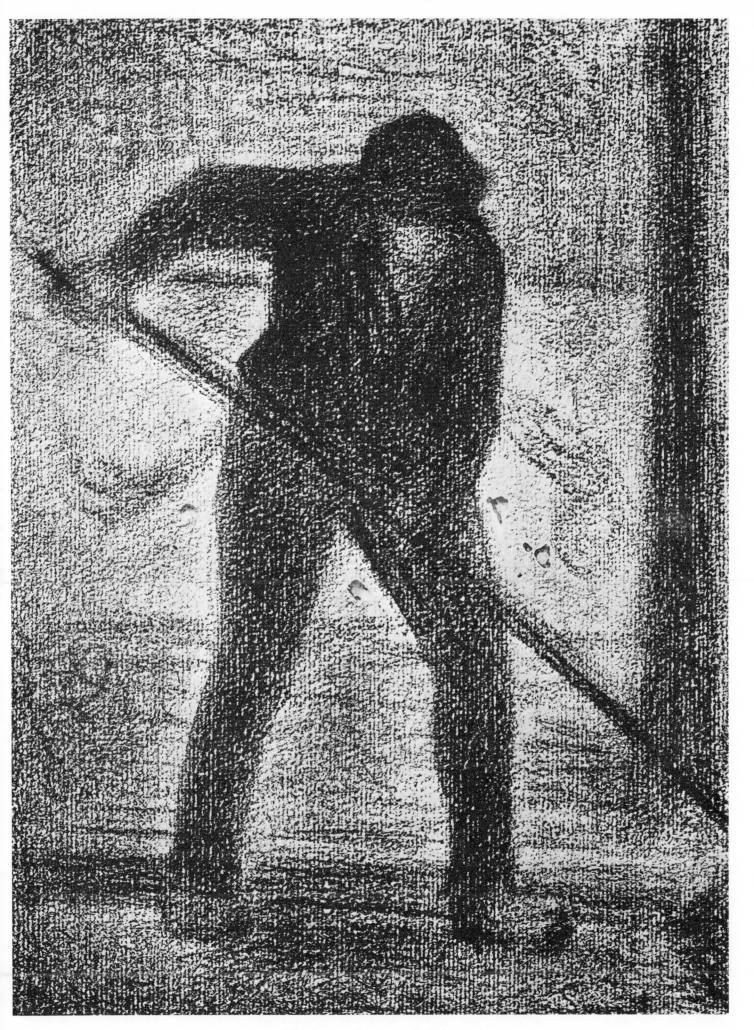

87. The street cleaner · *Le balayeur*

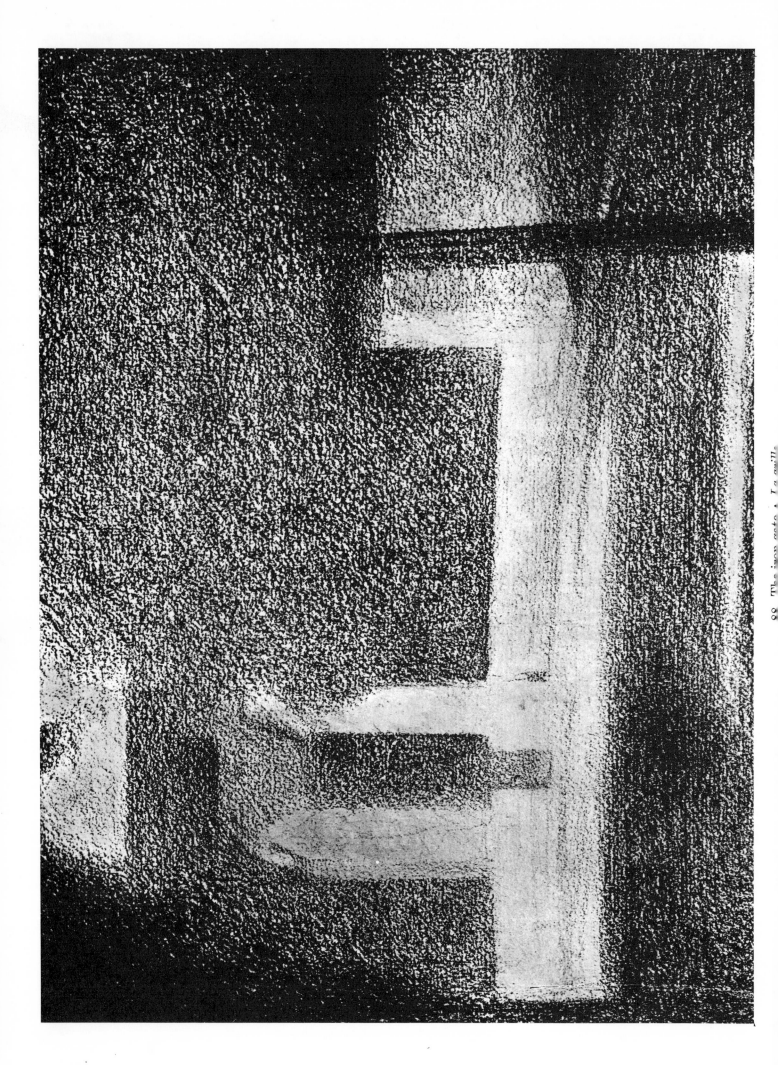

88. The iron gate: *La grille*

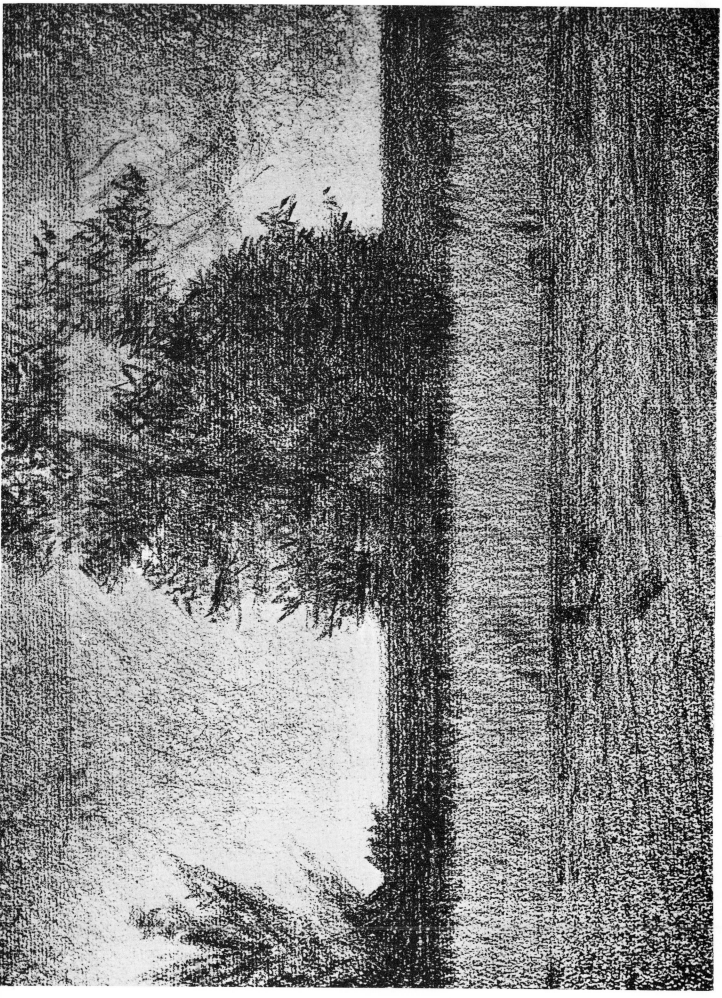

89. The tree · *L'arbre*

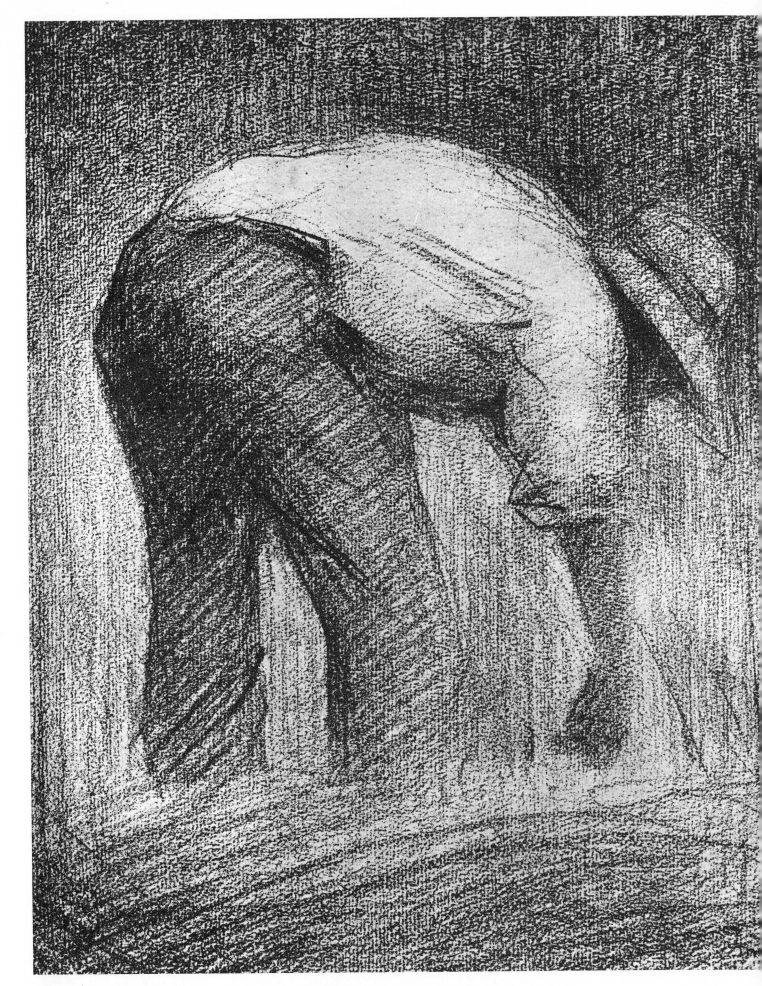

90. Harvester · *Moissonneur*

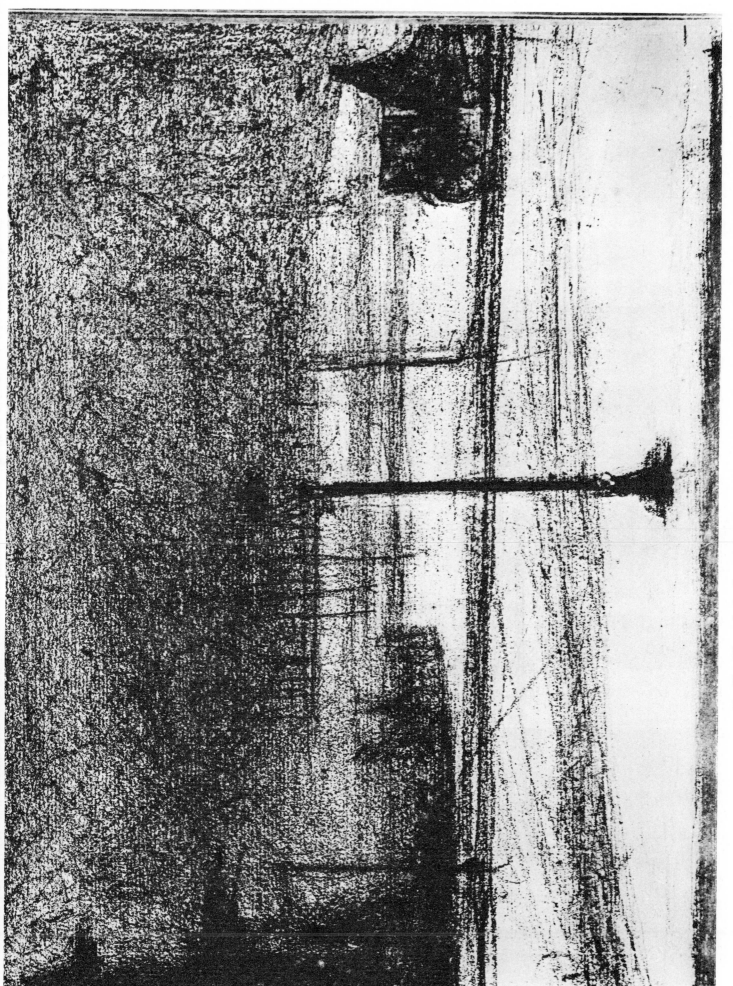

91. The Place de la Concorde in winter · *Place de la Concorde, hiver*

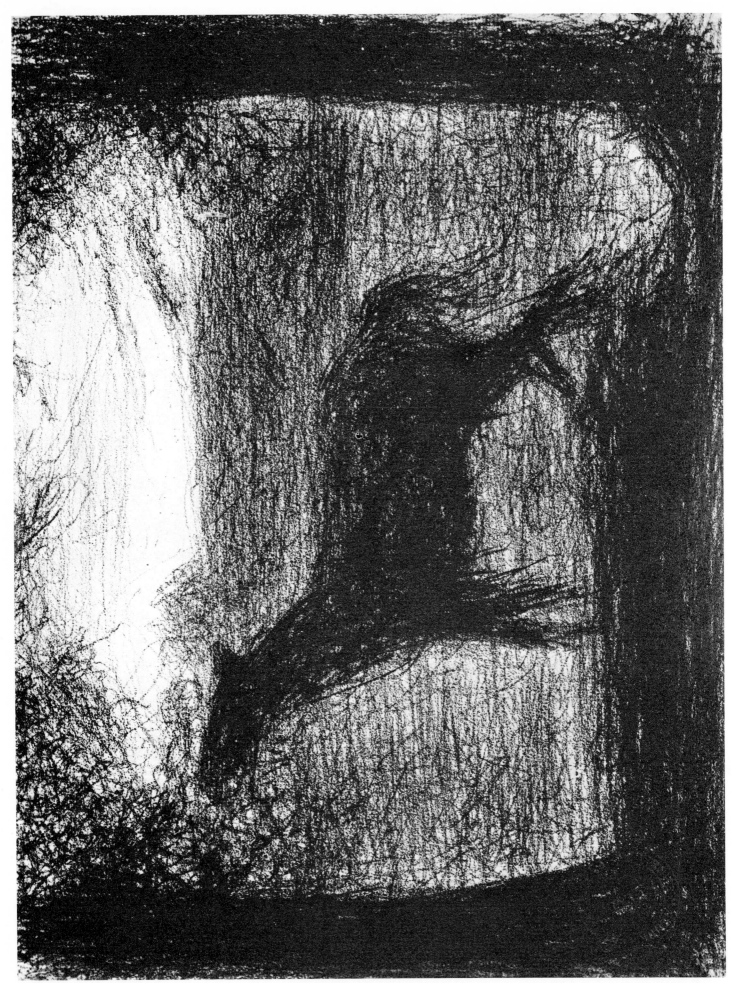

92. The colt · *Le poulain*

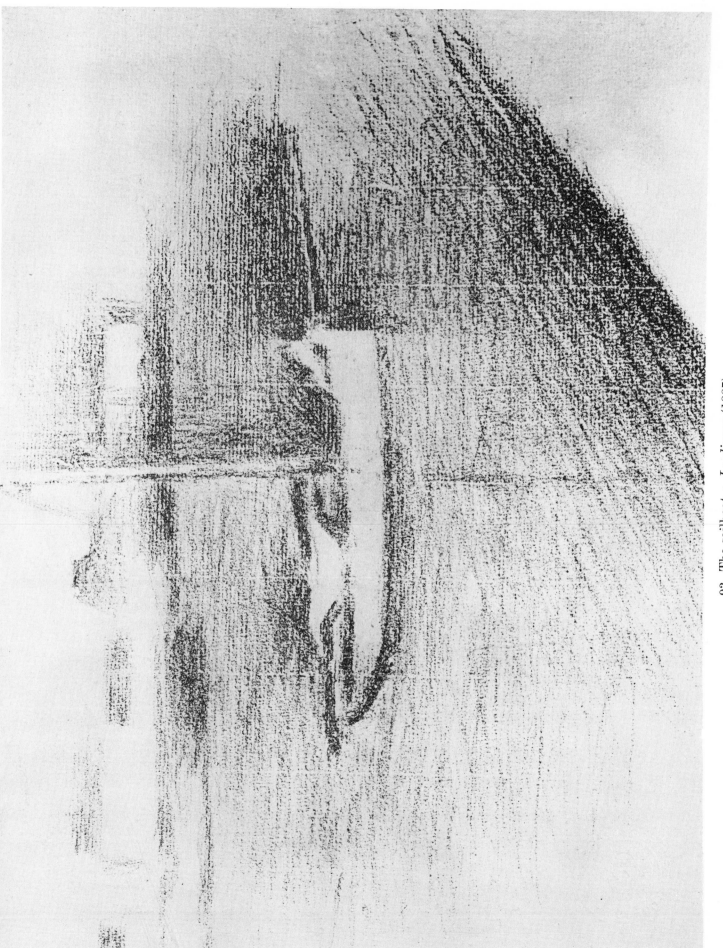

93. The sailboat · *Le clipper* (1887)

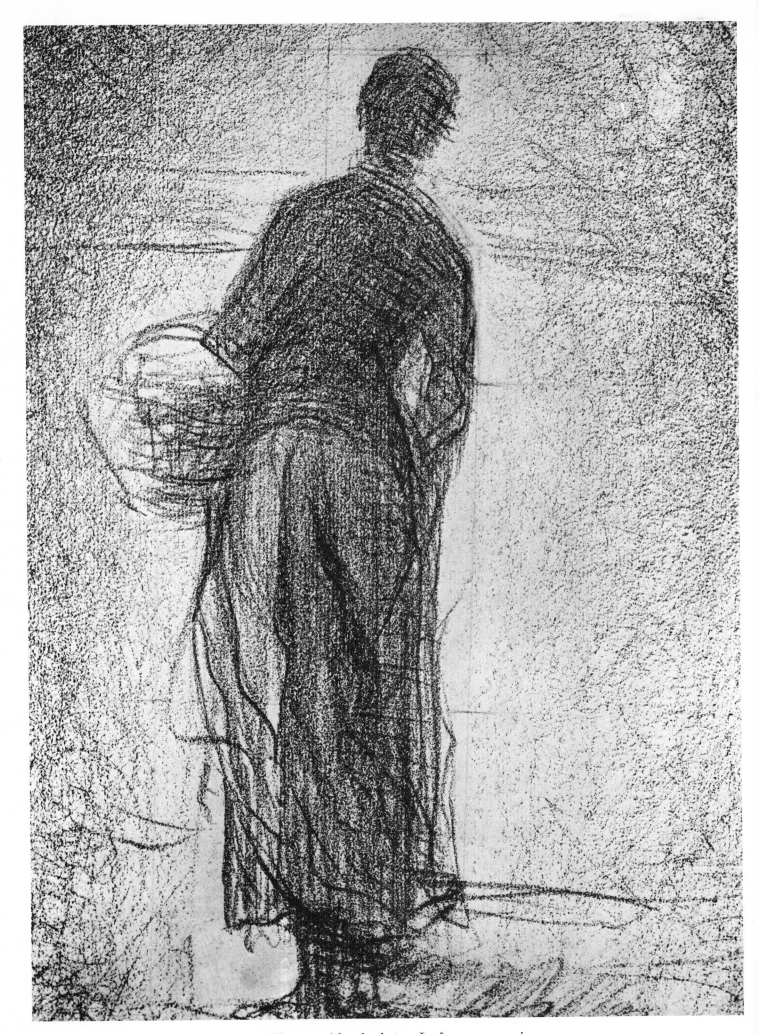

94. Woman with a basket · *La femme au panier*

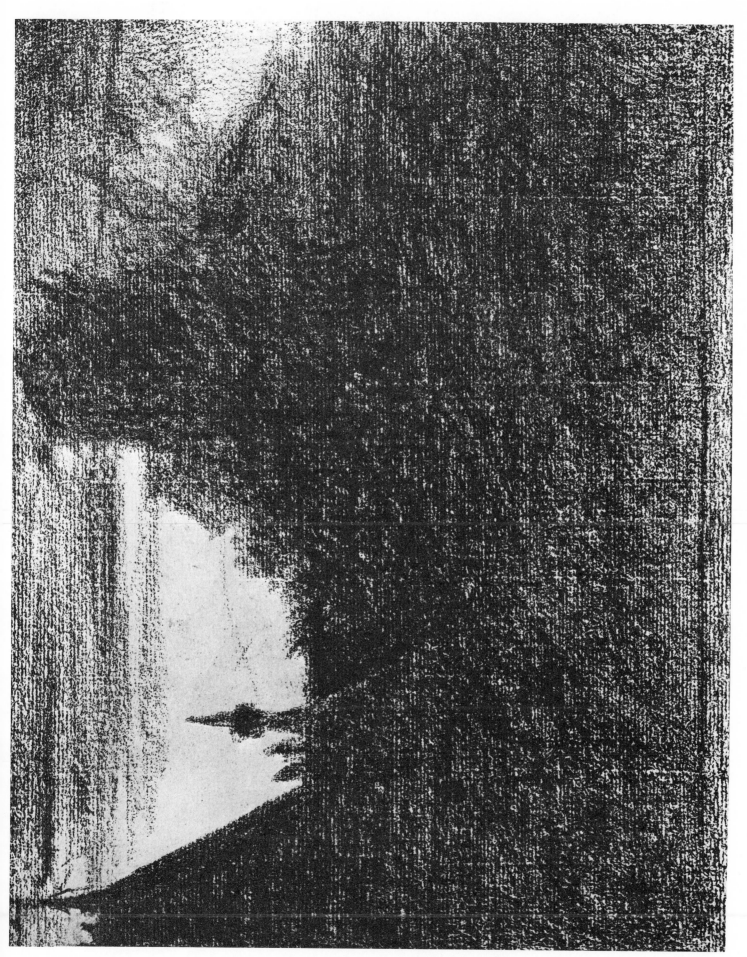

95. Bell turrets · *Clochetons*

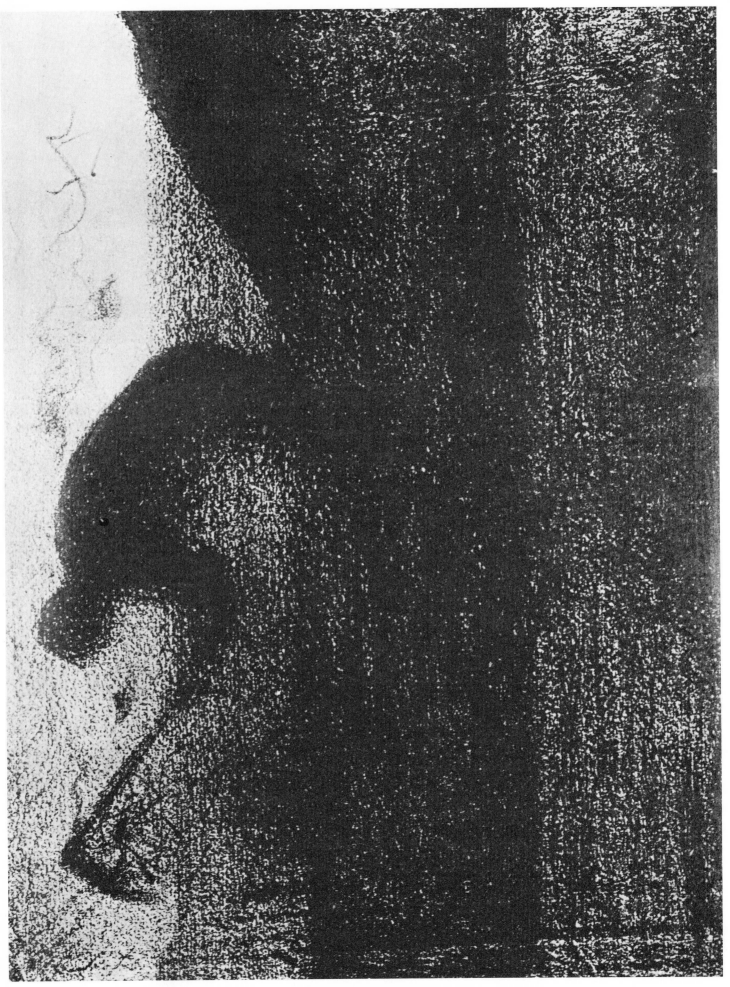

26. Man with a pick · *L'homme à la pioche*

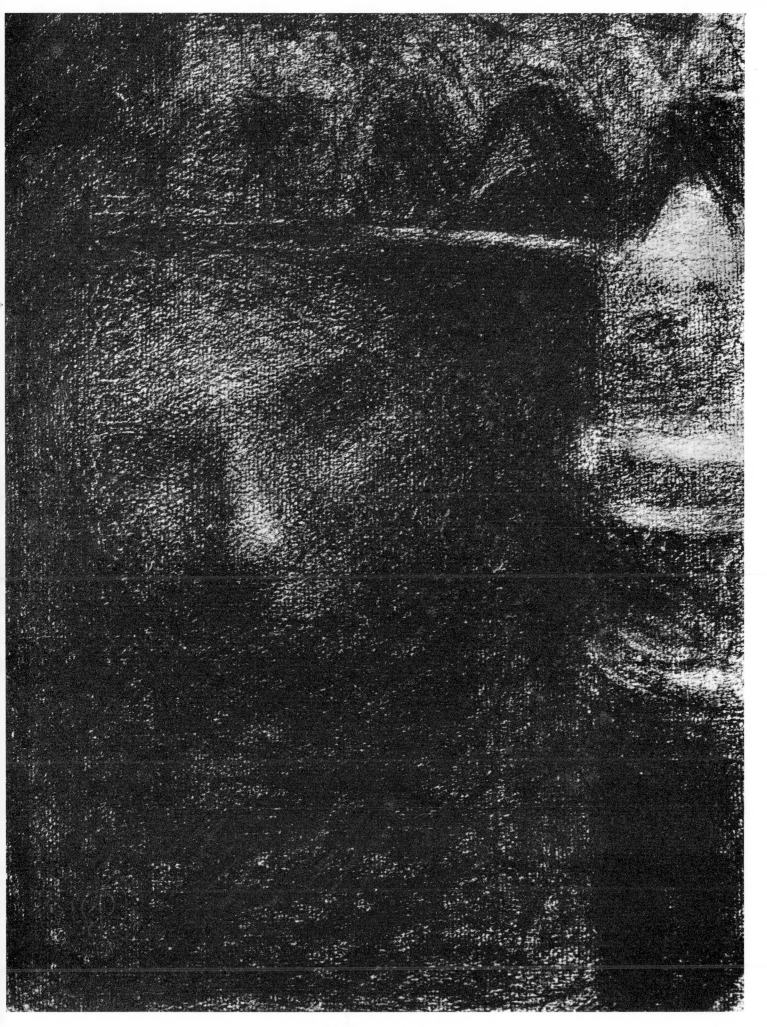

97. The lamp · *La lampe*

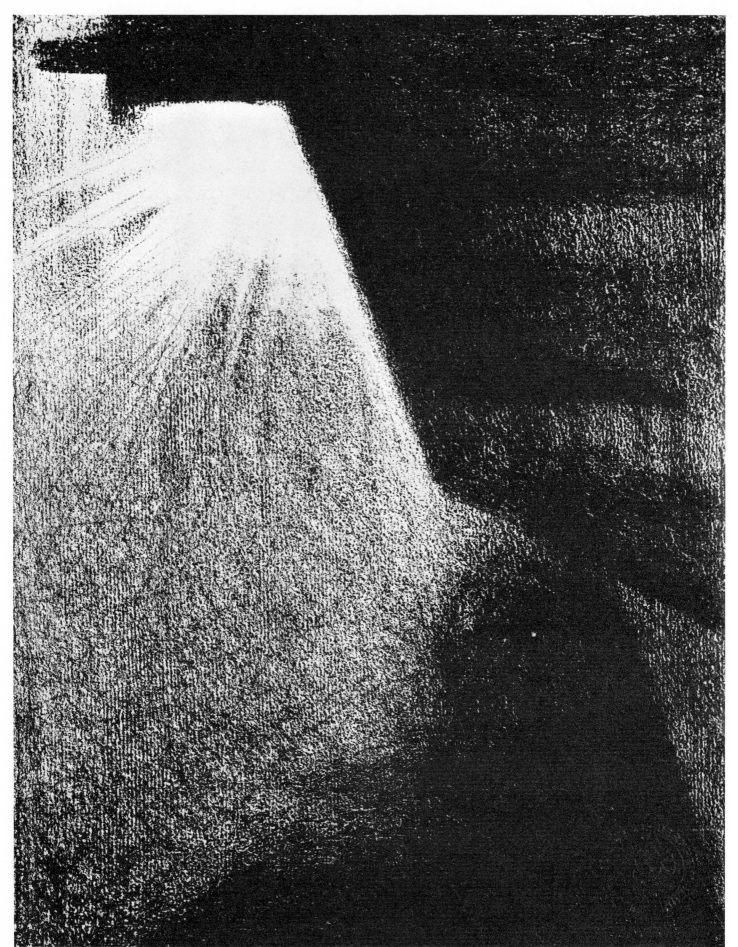

98. Sunbeams · *Rayons*

99. Door · *Porte*

100. Factories by moonlight · *Usines sous la lune*

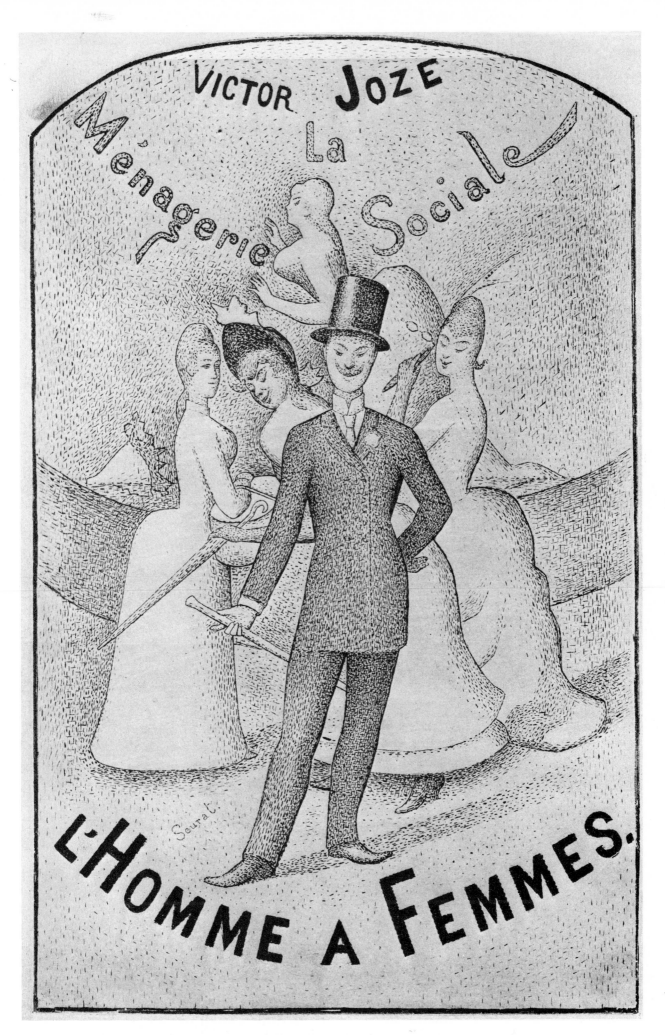

101. "The Ladies' Man" • "*L'Homme à femmes*"

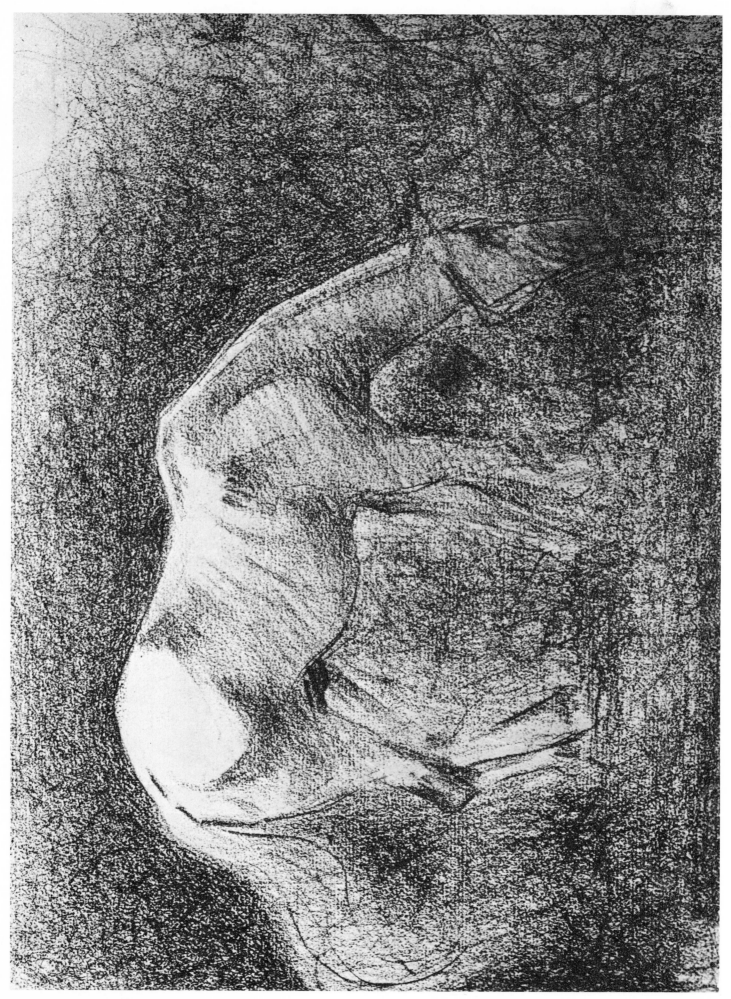

102. The horse · *Le cheval*

103. The black horse · *Le cheval noir*

104. Breakwaters at Gravelines · *Estacade de Gravelines* (1890)

105. The leg · *La jambe*

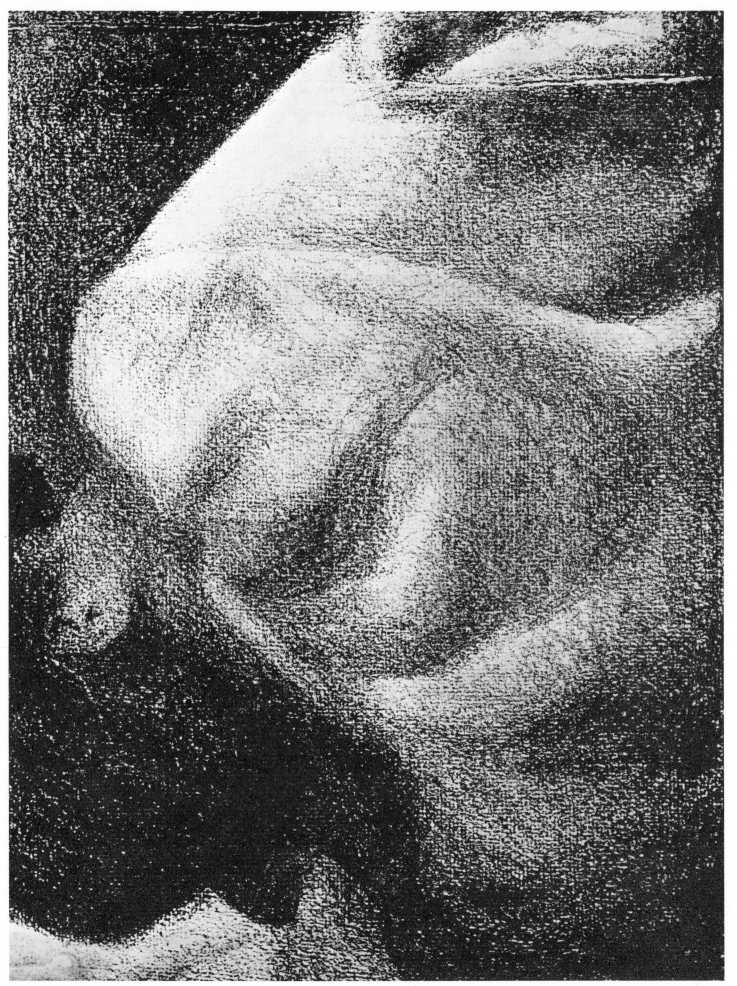

106 First version of "Man sleeping" · *Première version du dormeur*

107. Man sleeping · *Le dormeur*

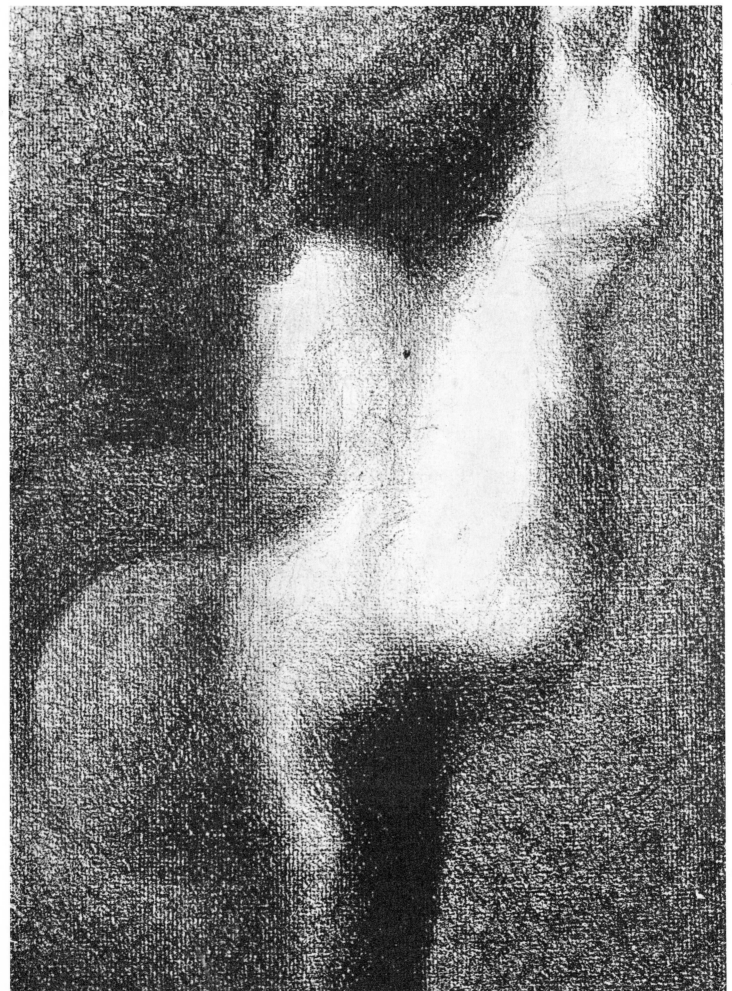

108. Hat, shoes, linen · *Chapeau, souliers, linge*

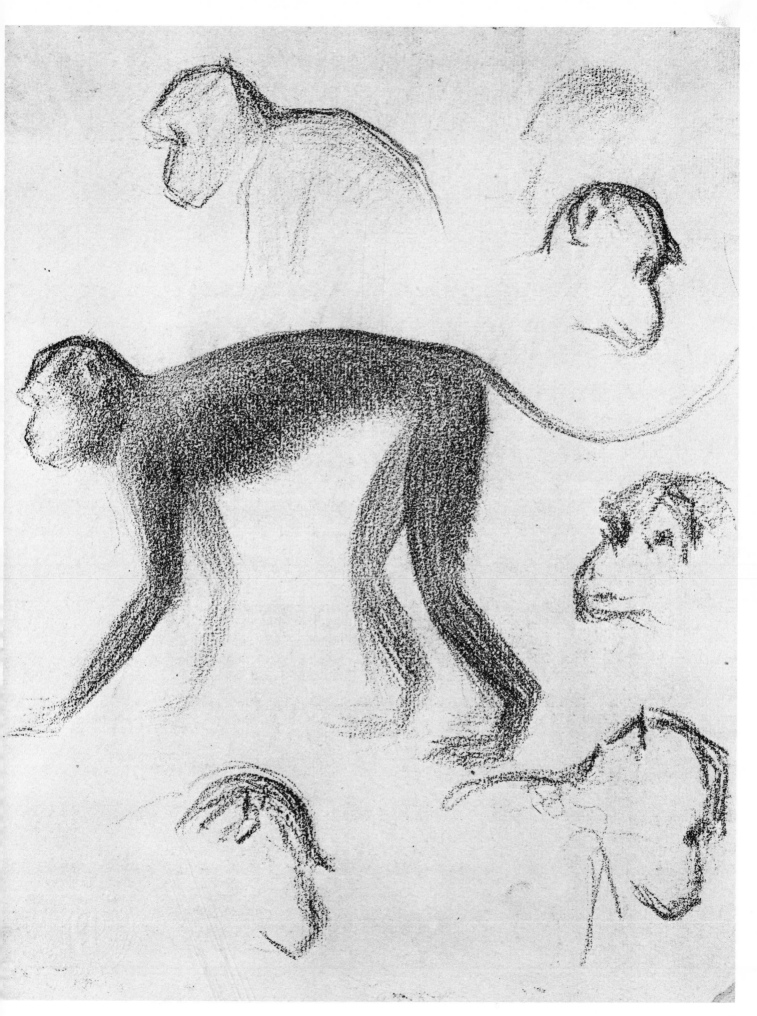

109. Monkeys · *Singes*

110. Monkey · *Singe*

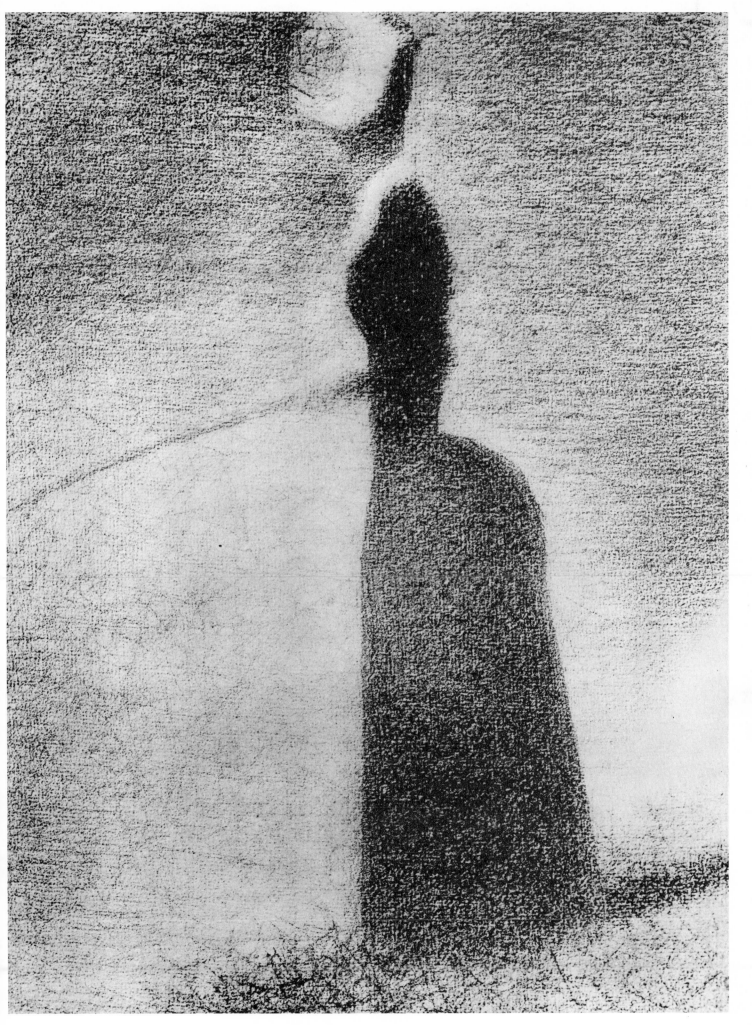

111. Woman fishing · *La pêcheuse à la ligne*

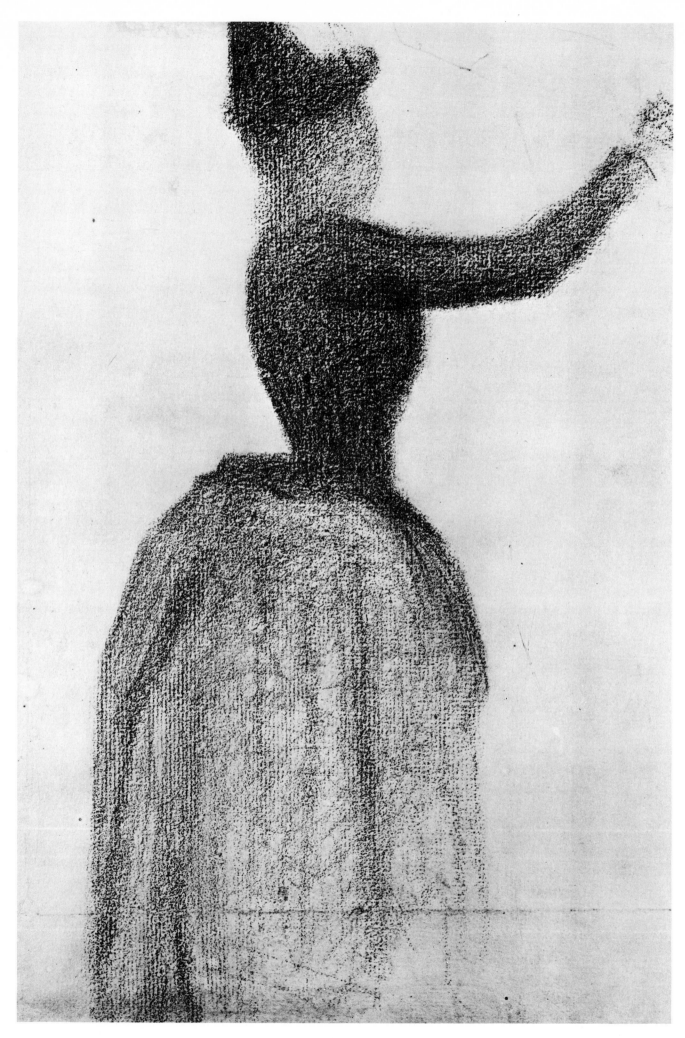

112. An upraised arm · *Un bras levé*

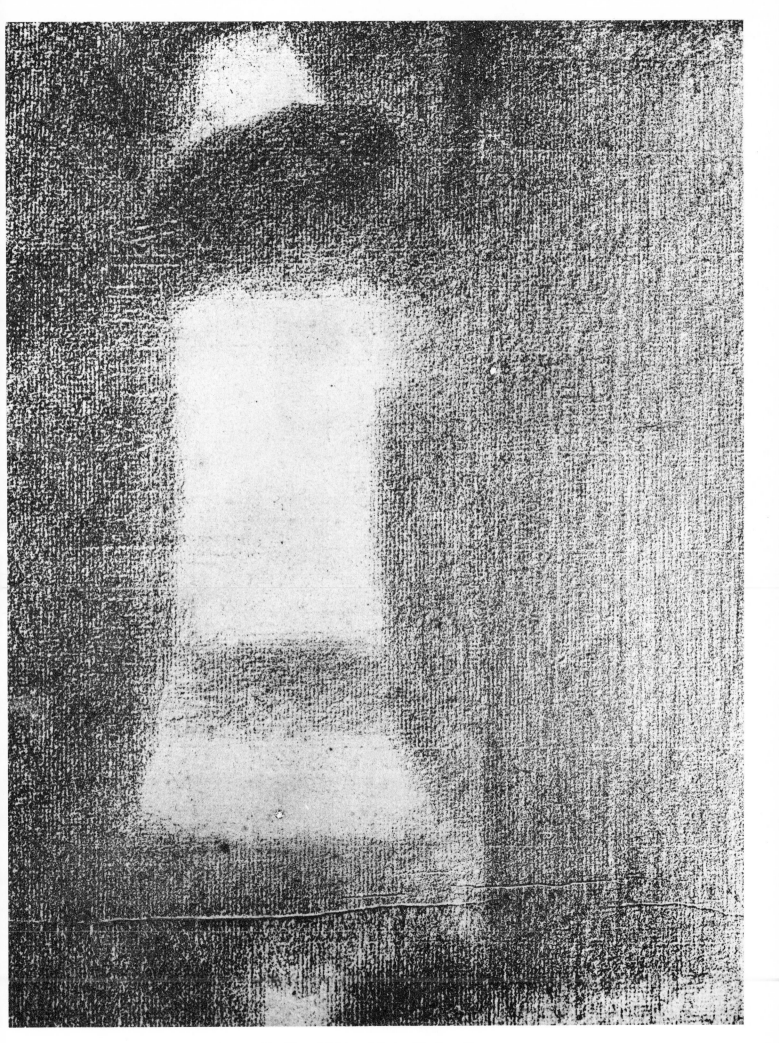

113. The child in white · *L'enfant blanc*

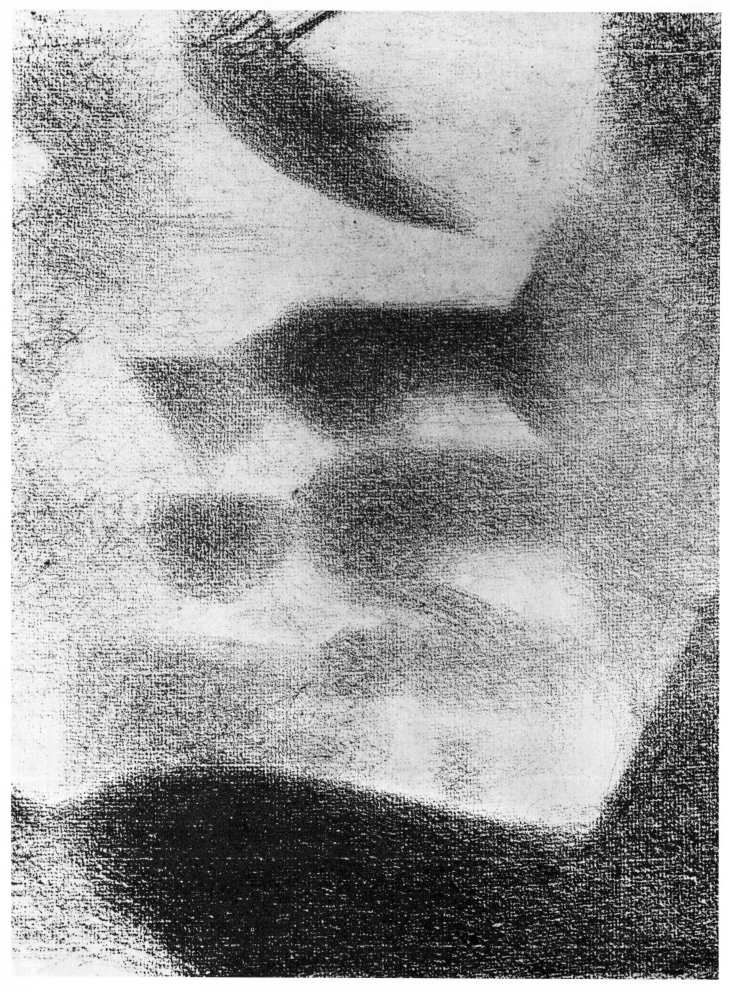

114. The girls · *Les jeunes filles*

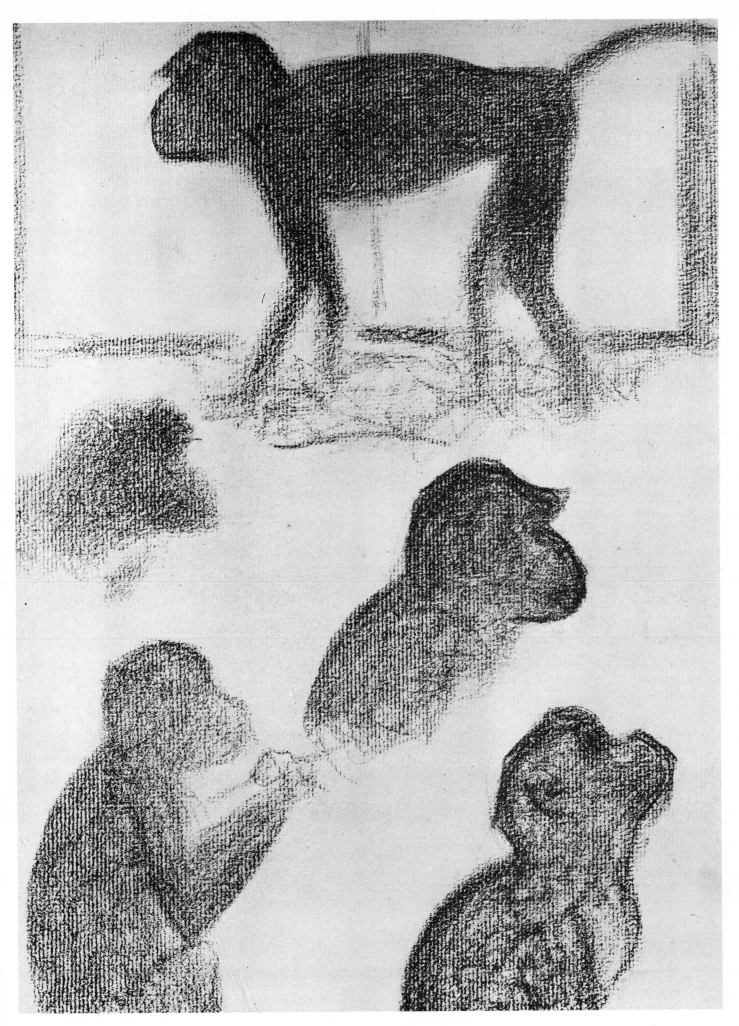

115. Five monkeys · *Cinq singes*

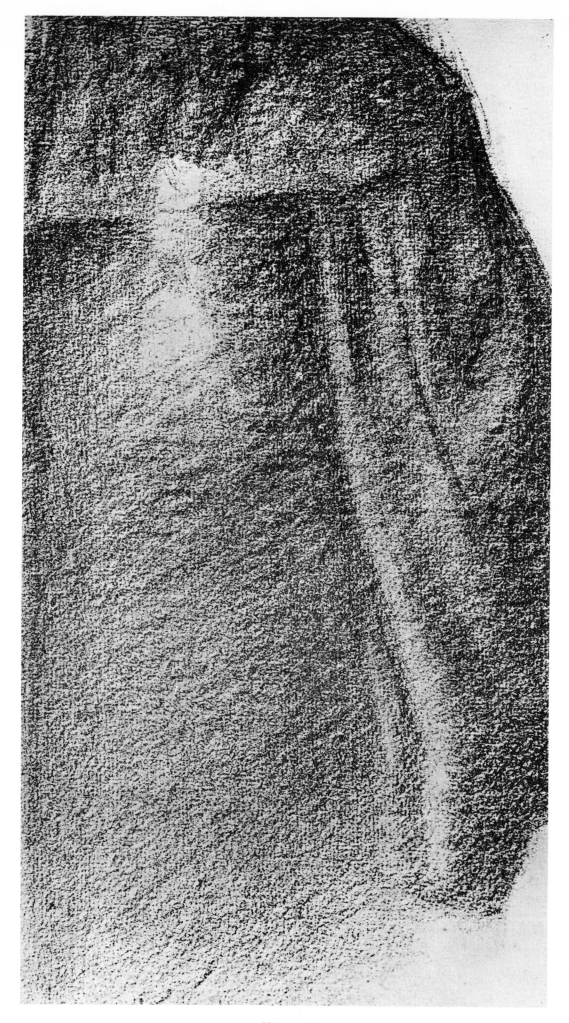

116. Skirt · *Jupe*

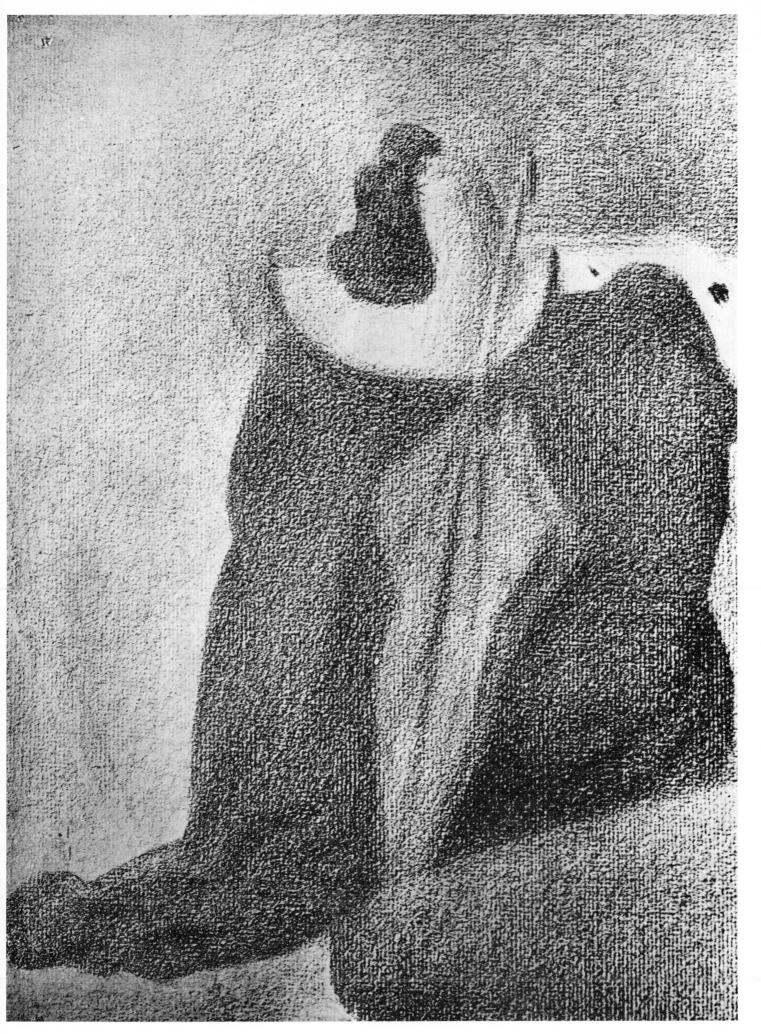

117. Still life · *Nature morte*

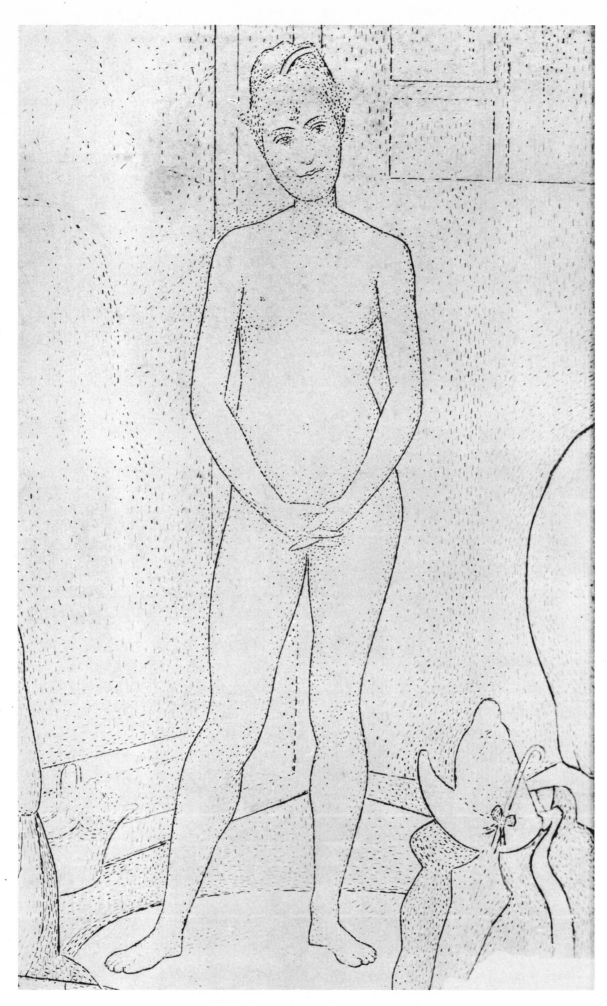

118. Model, front view · *La poseuse, de face*

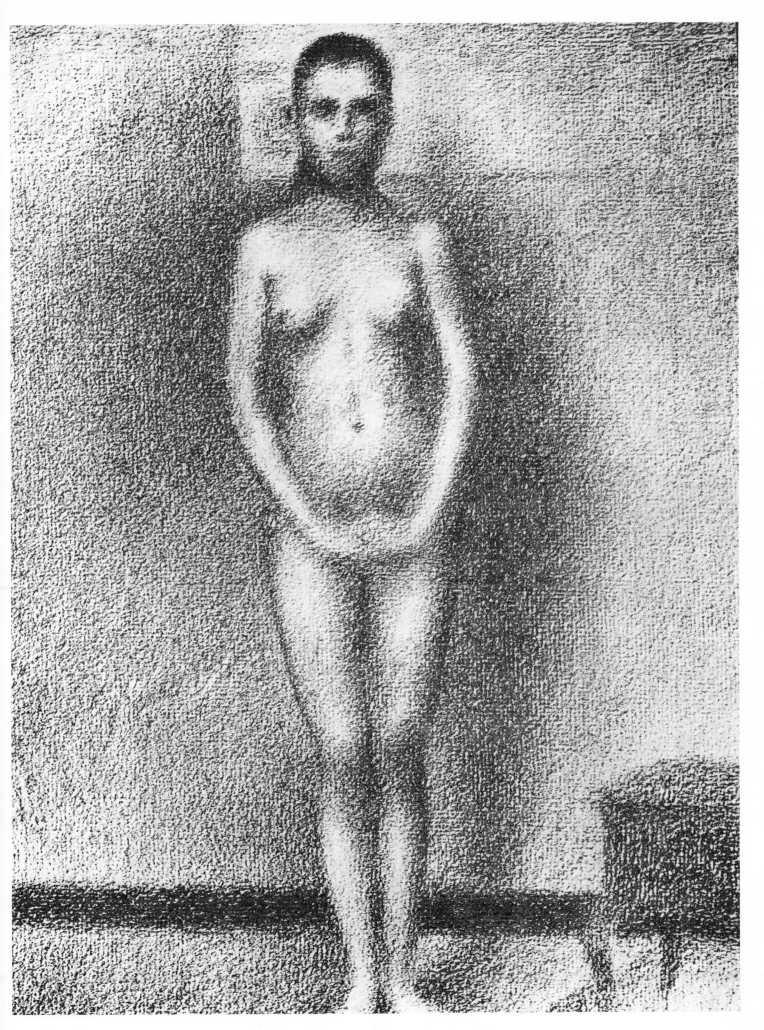

119. Model, front view · *La poseuse, de face*

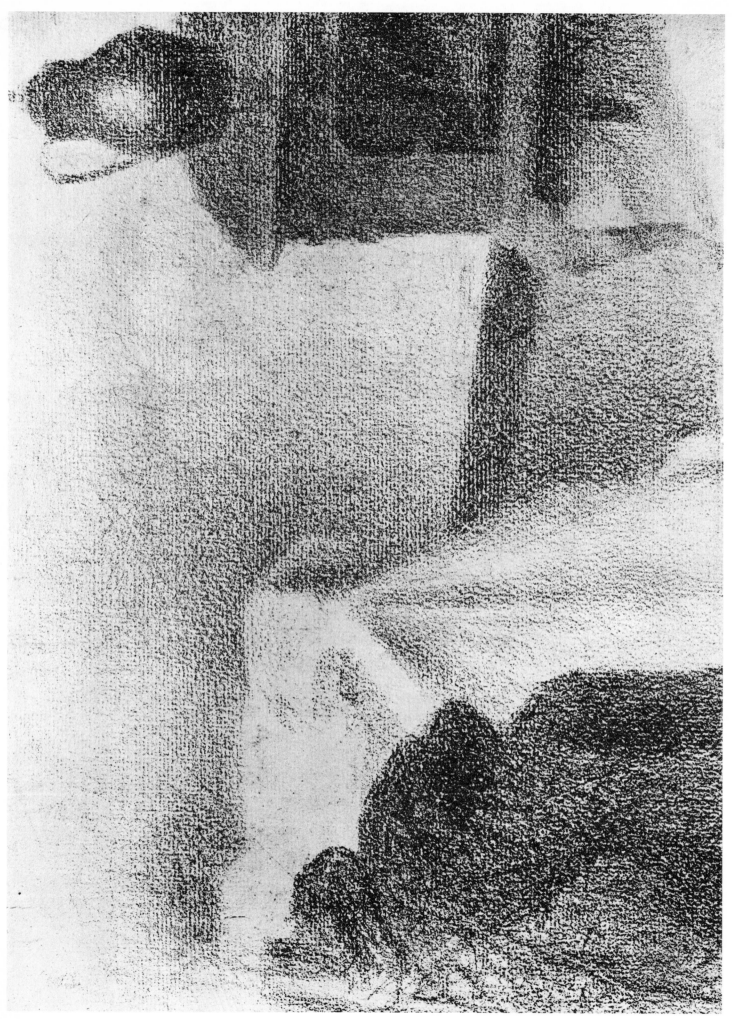

120. The stove · *Le fourneau*

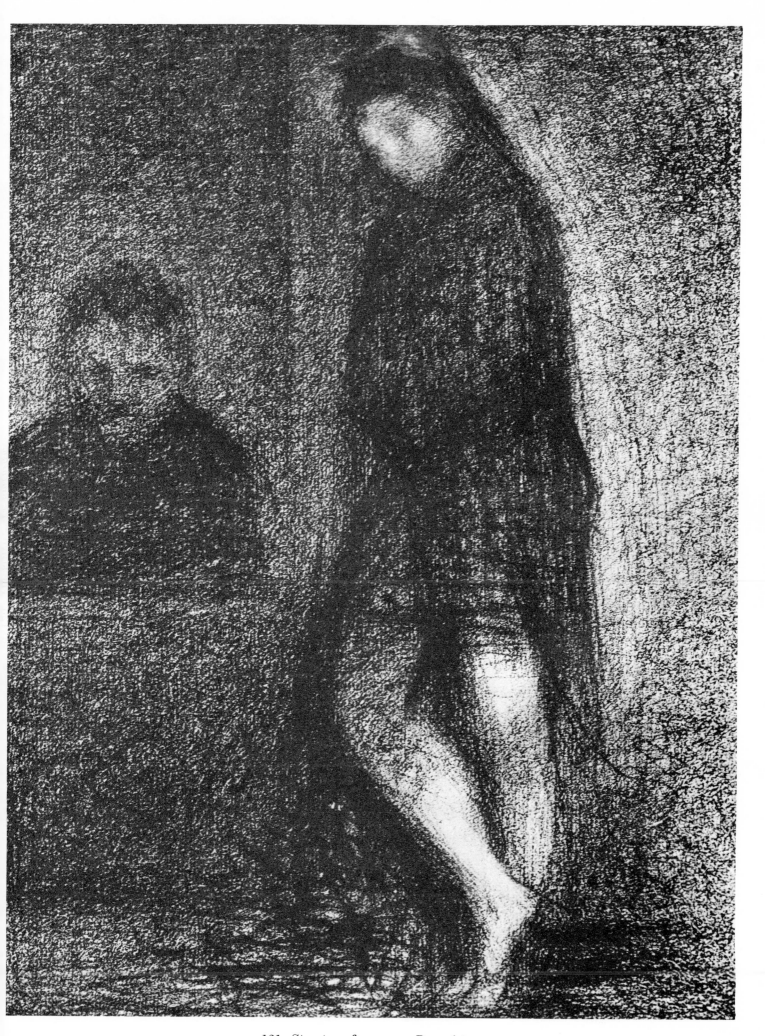

121. Street performers · *Banquistes*

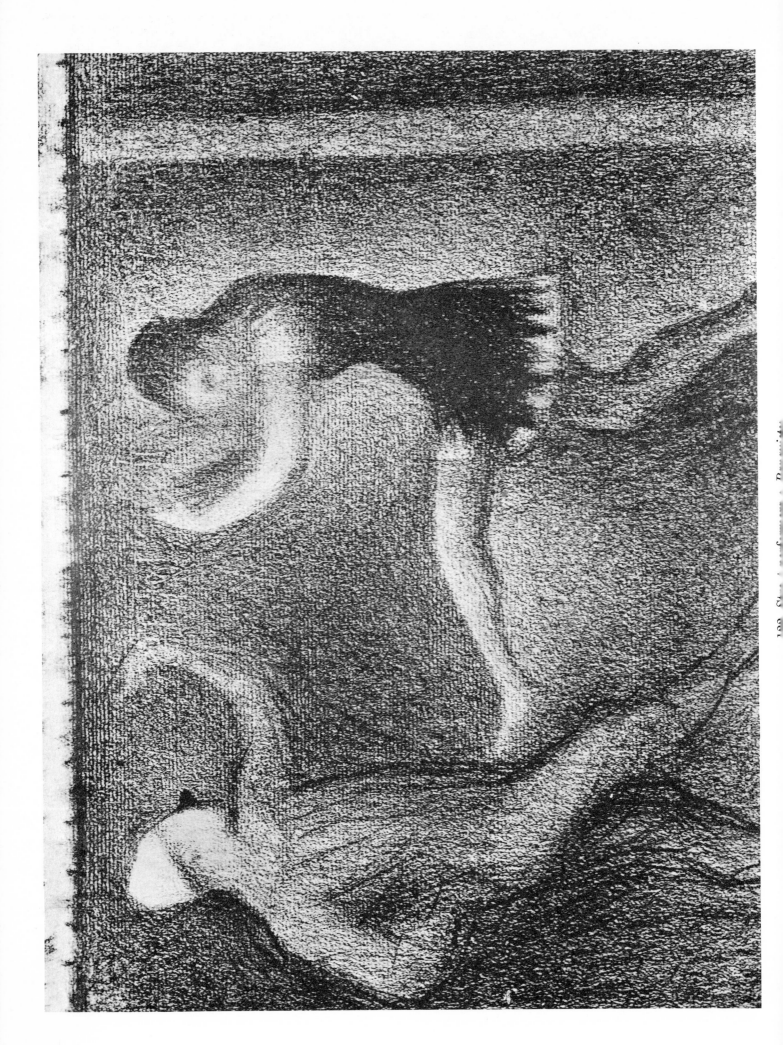

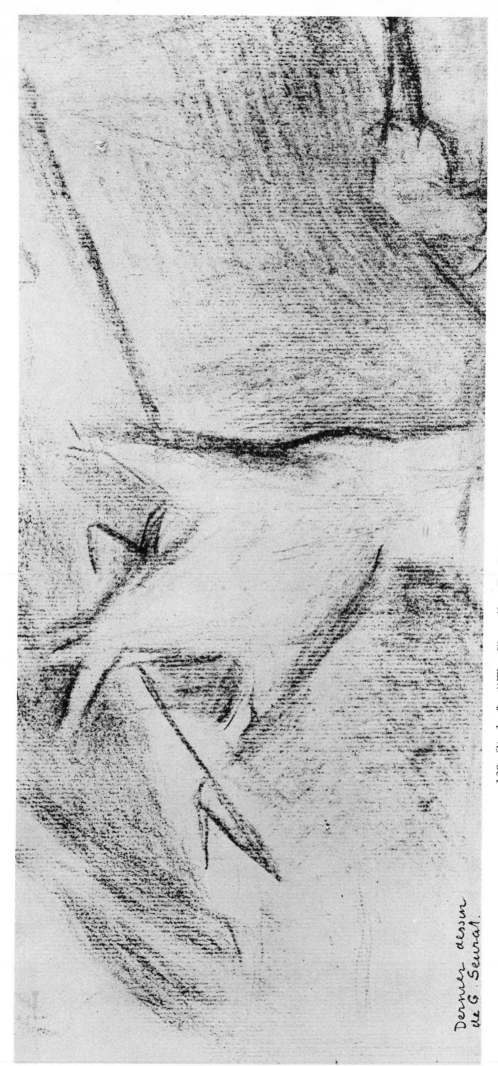

Dernier dessin
de G. Seurat.

123. Study for "The Circus" • *Etude* (1890) *pour* "*Le Cirque*"
(Inscribed: "Dernier dessin de G. Seurat" [Last drawing by G. Seurat])

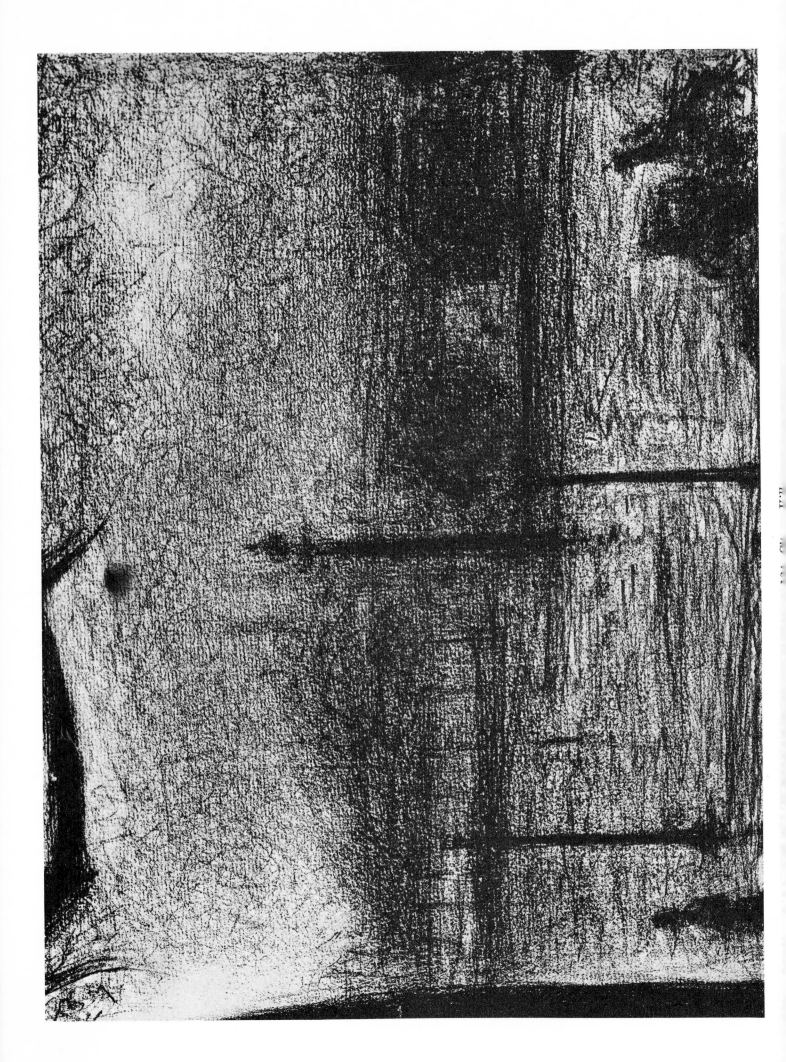

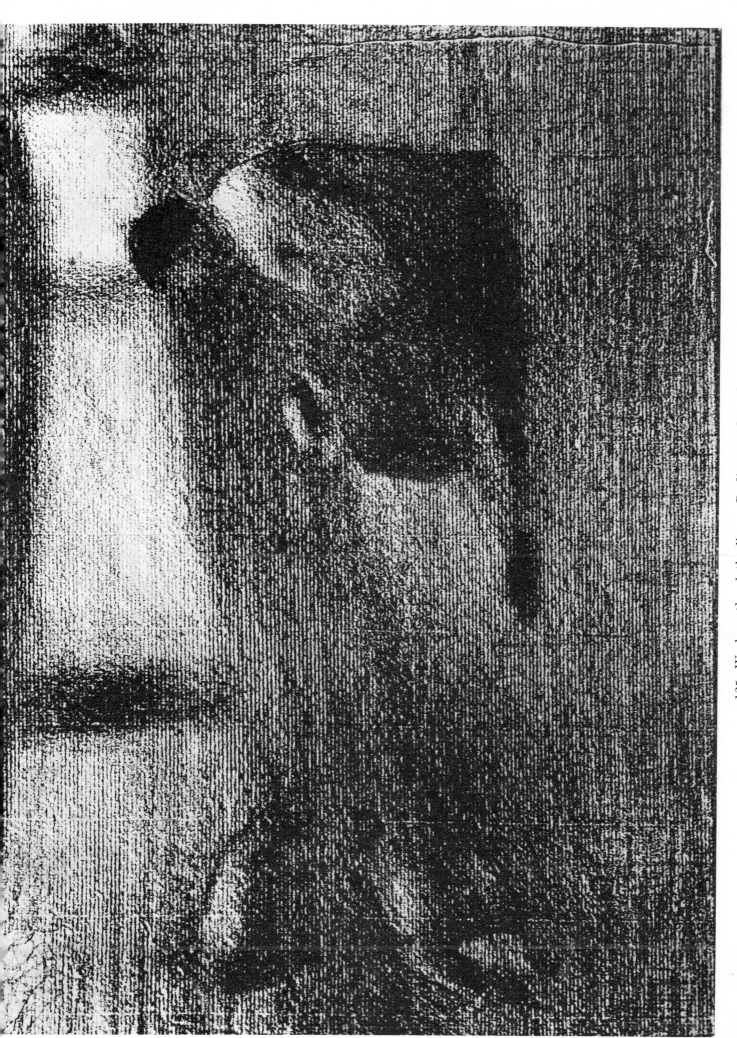

125. Wash on the clothesline · *Du linge sur le cordeau*

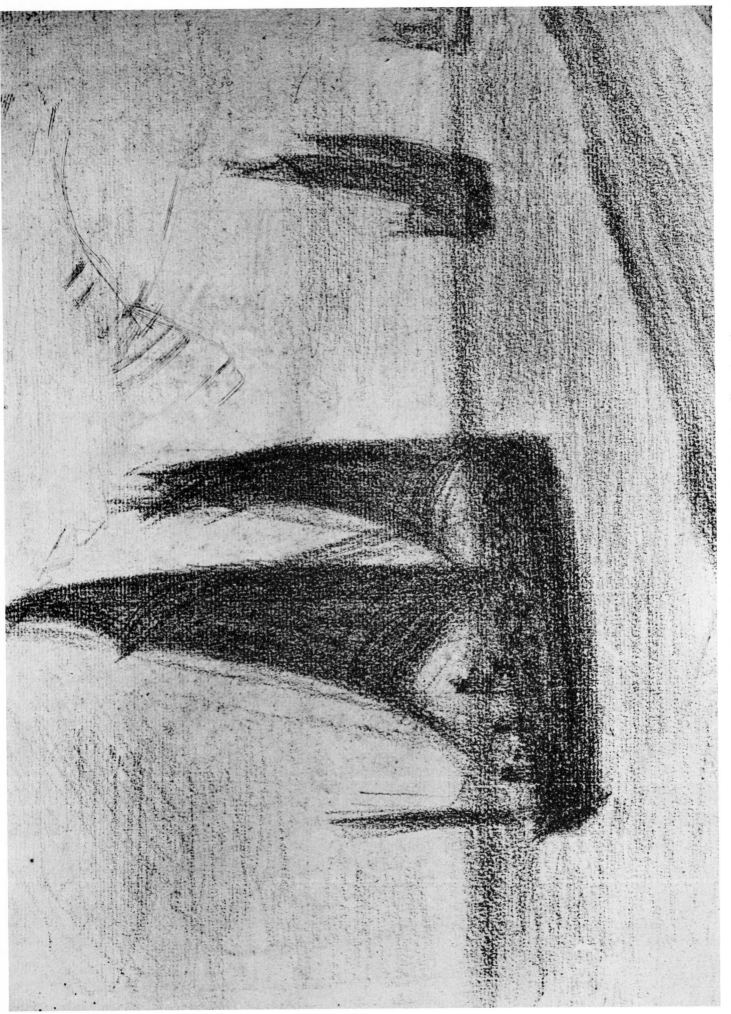

126. Channel at Gravelines • Chenal de Gravelines (1890)

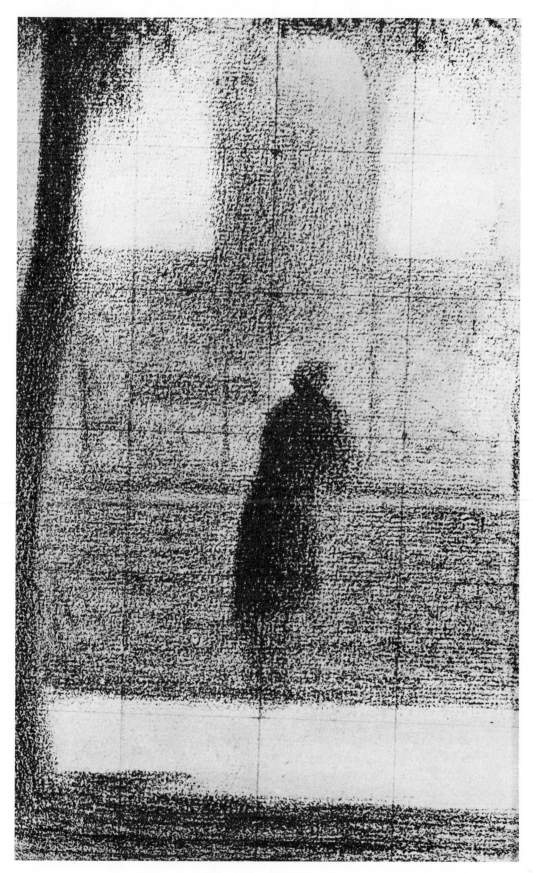

127. The invalid · *L'invalide*

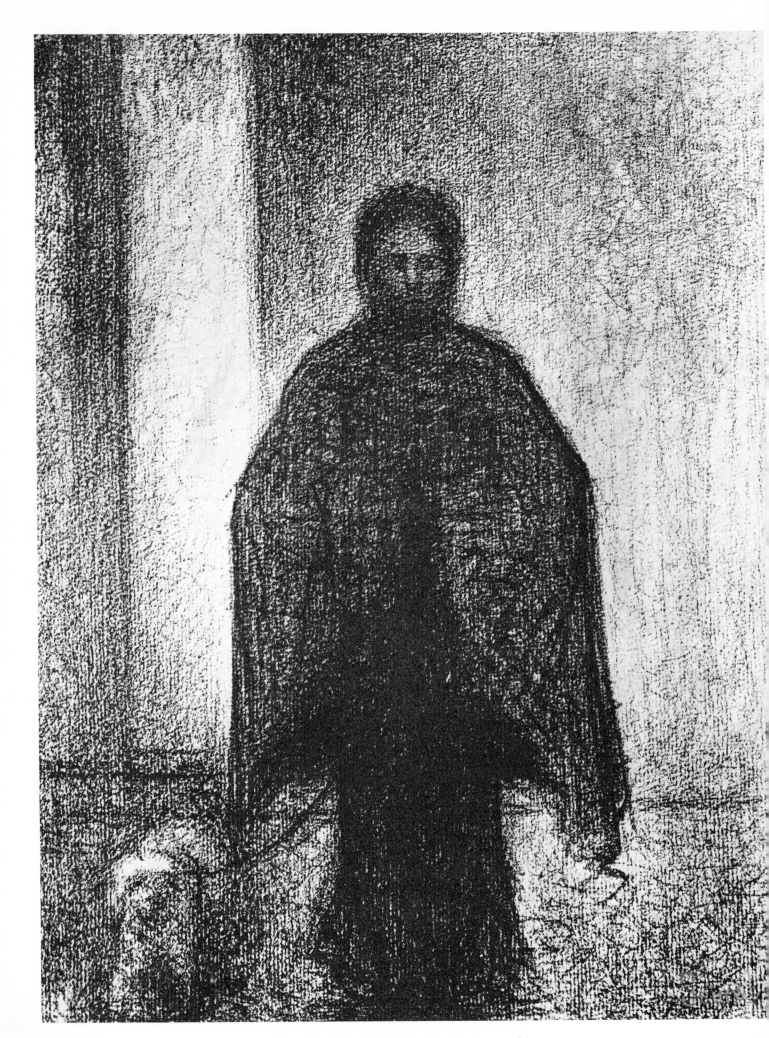

128. Woman with a dog · *La femme au chien*

129. Wheat and trees · *Blé et arbres*

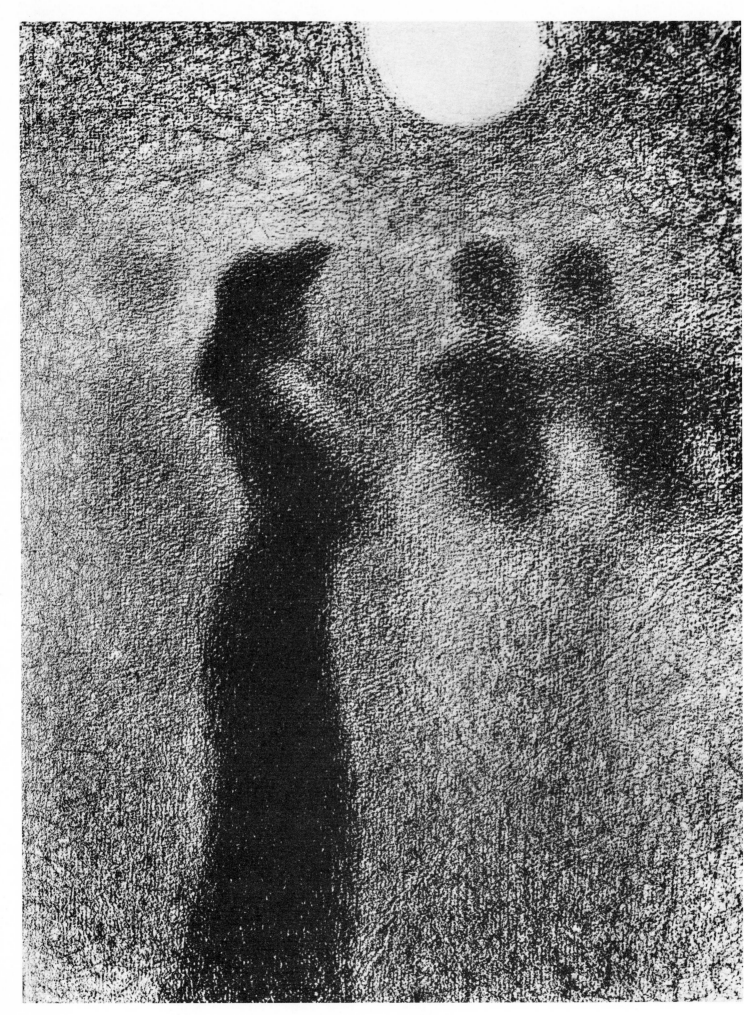

130. Promenade · *Promenoir*

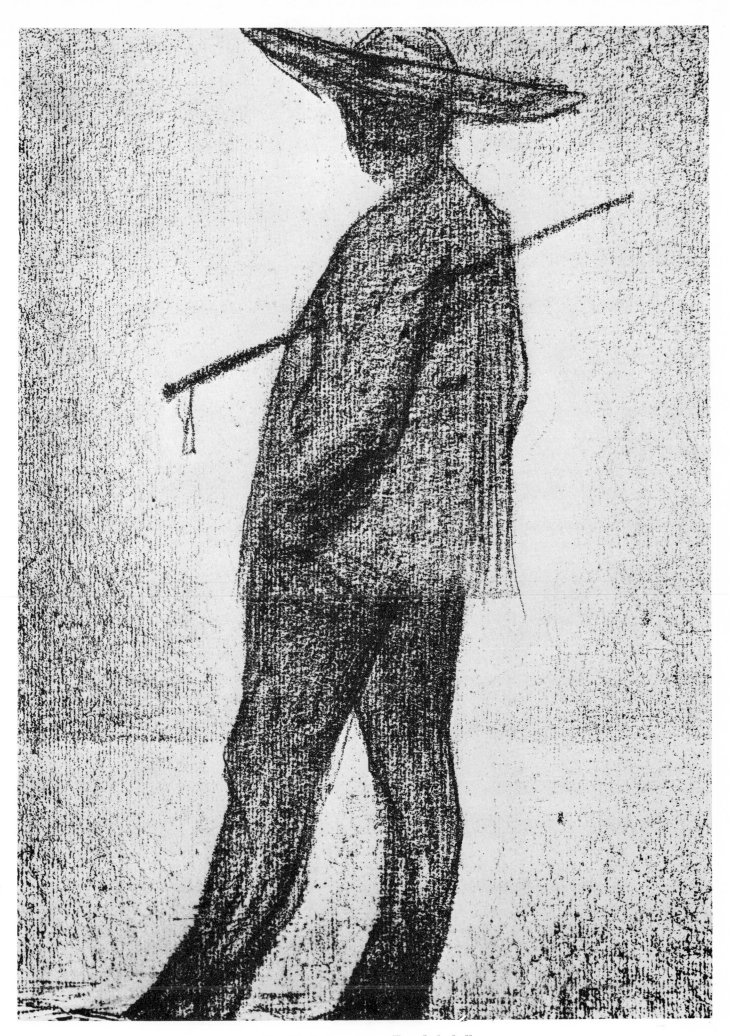

131. Market porter · *Fort de la halle*

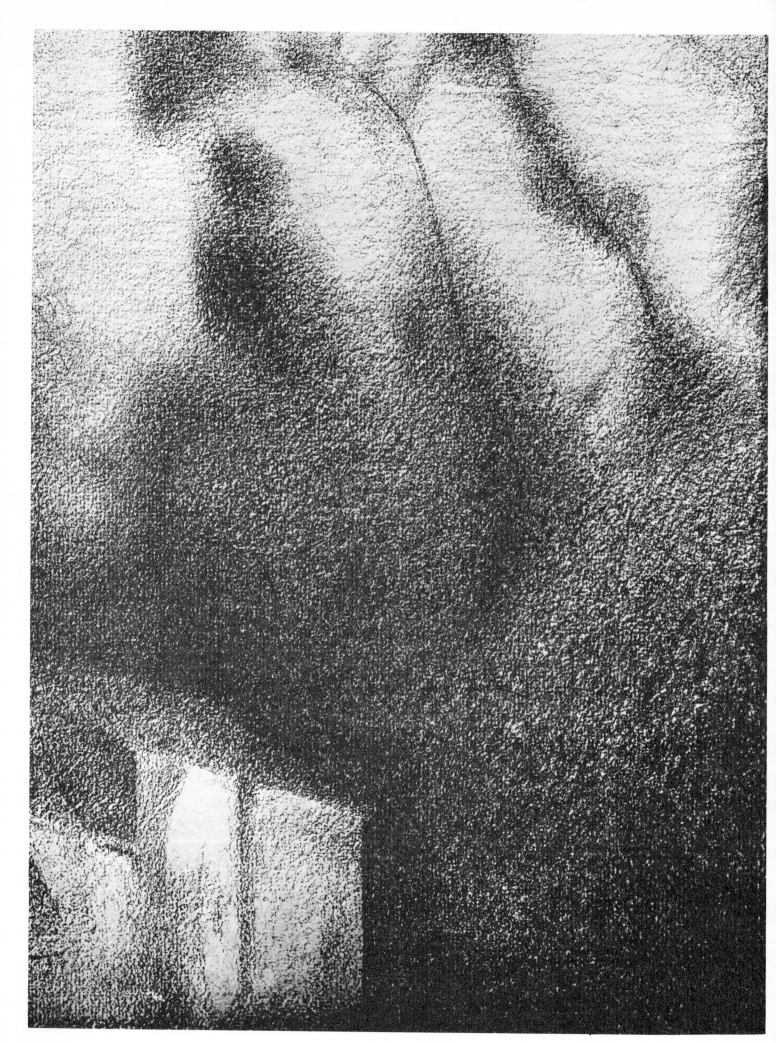

132. Haunted house · *Maison hantée*

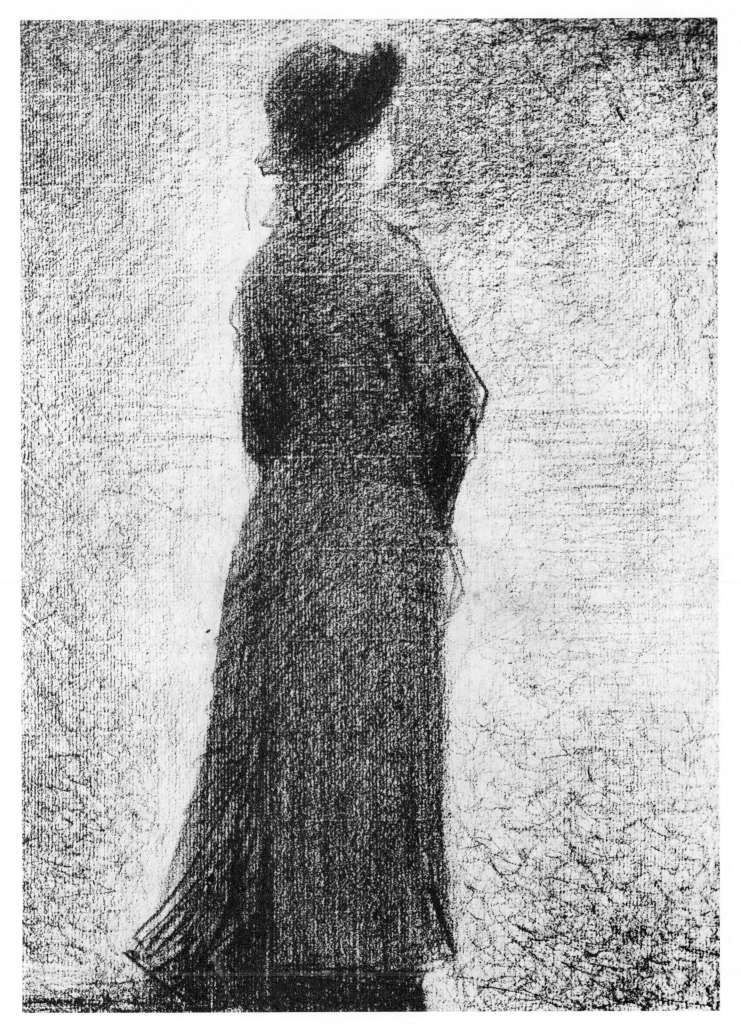

133. Silhouette · *Silhouette*

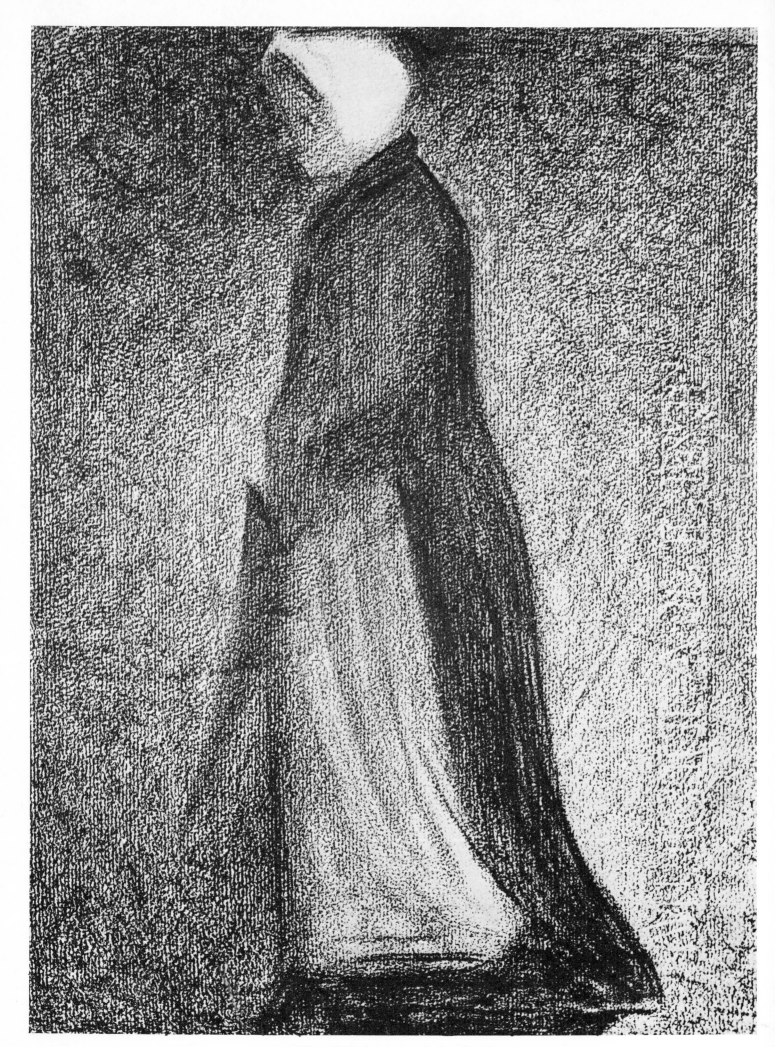

134. The white bonnet · *Le bonnet blanc*

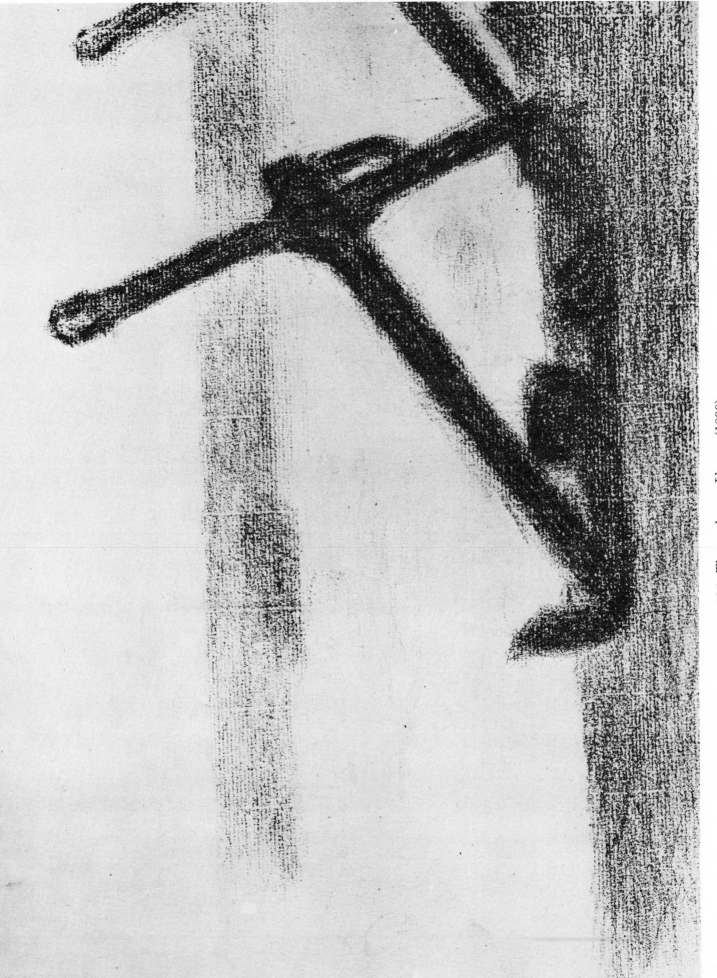

135. The anchor · *L'ancre* (1890)

137. Nurse · *Nourrice*

136. The white tunic · *La jaquette blanche*

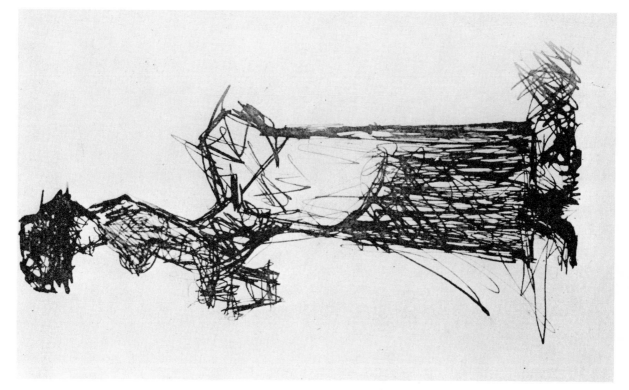

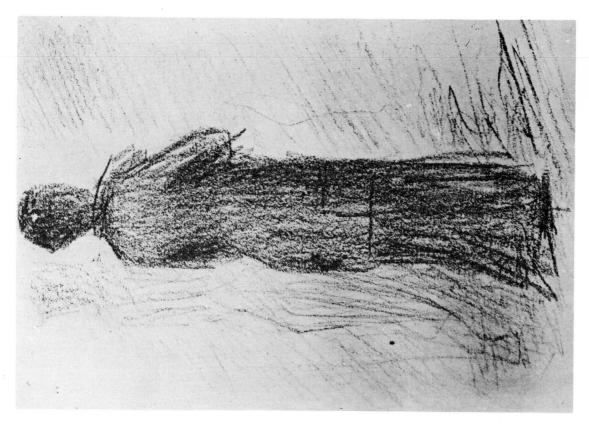

138 & 139. Silhouettes of women · *Silhouettes de femmes*

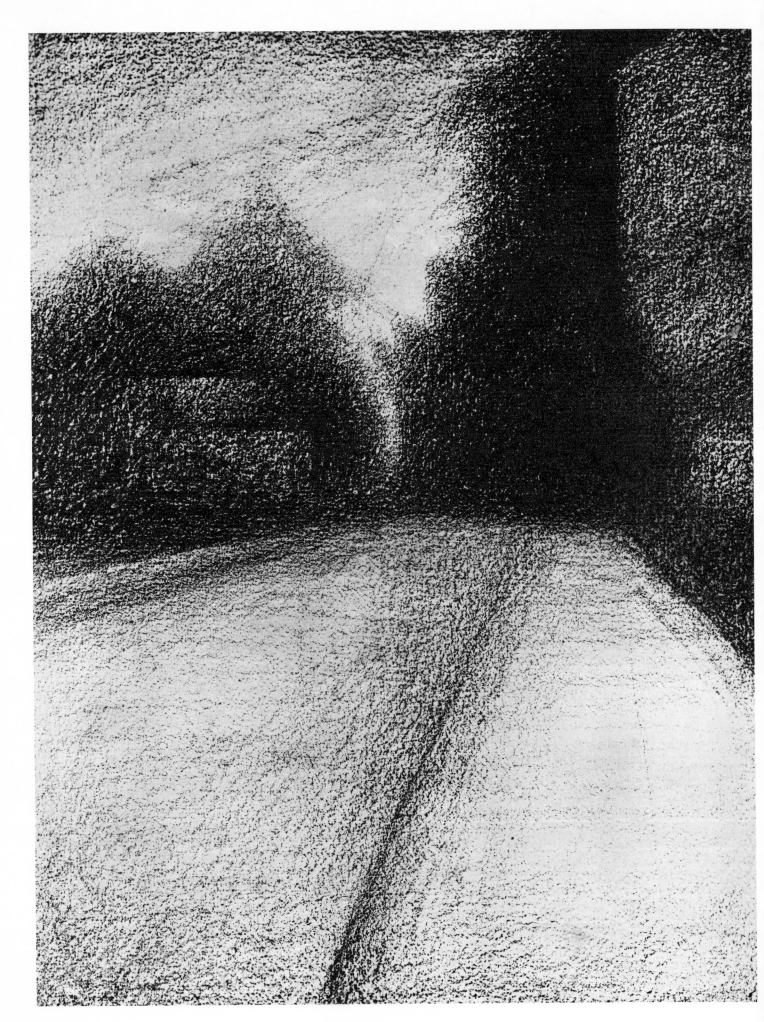

140. The road · *La route*

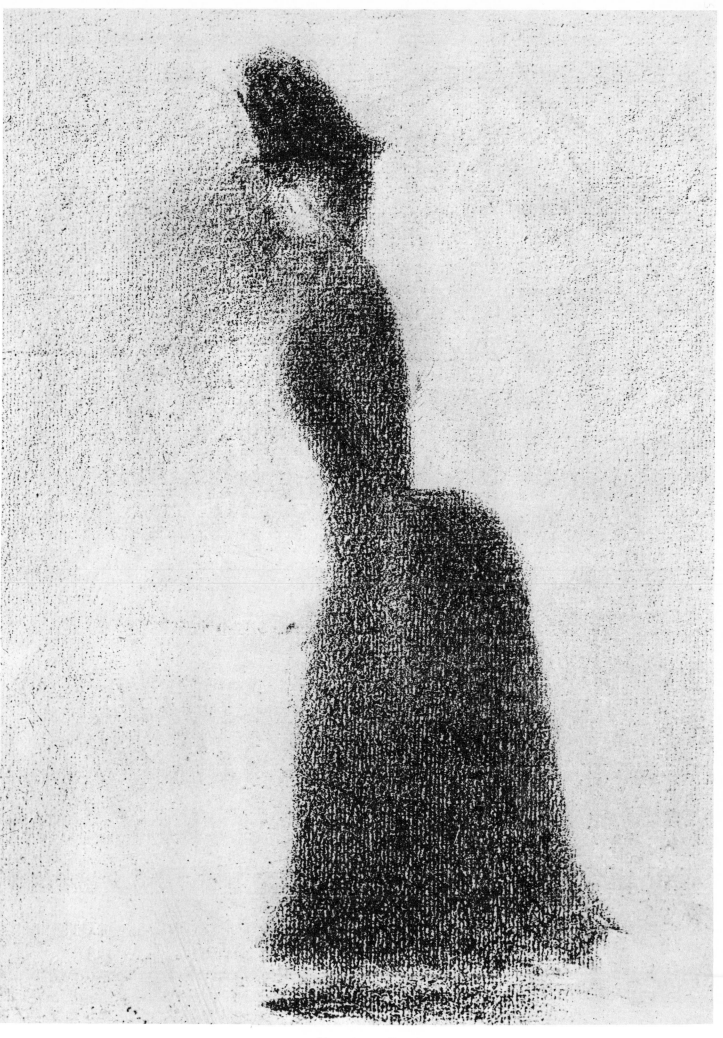

141. Drawing · *Dessin*

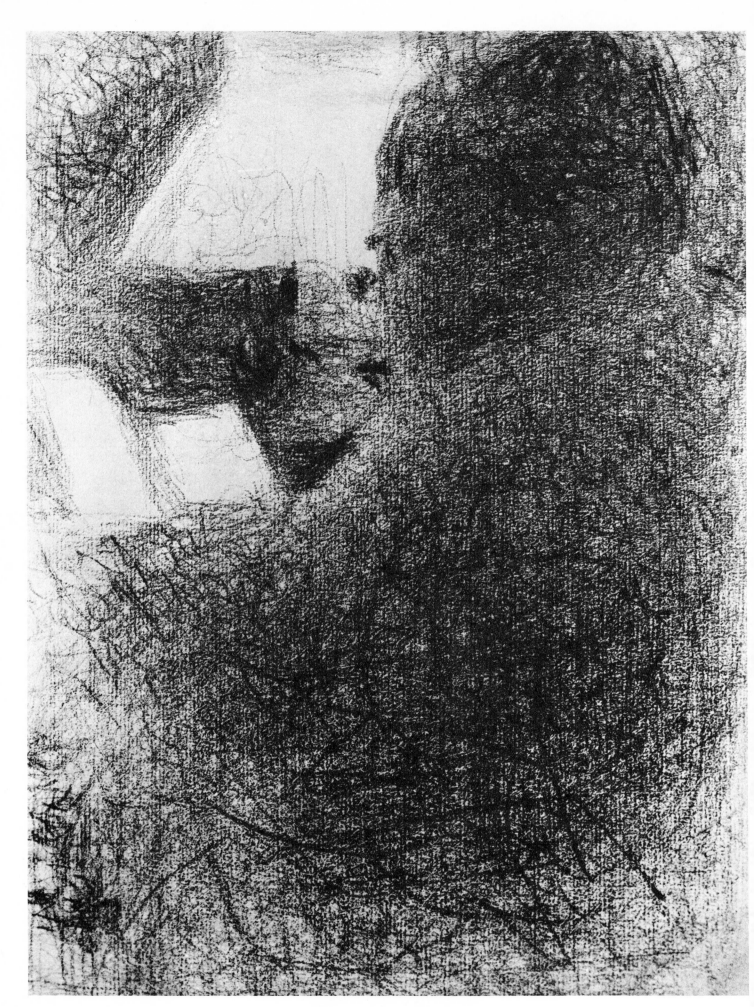

142. Study of a woman · *Etude de femme*

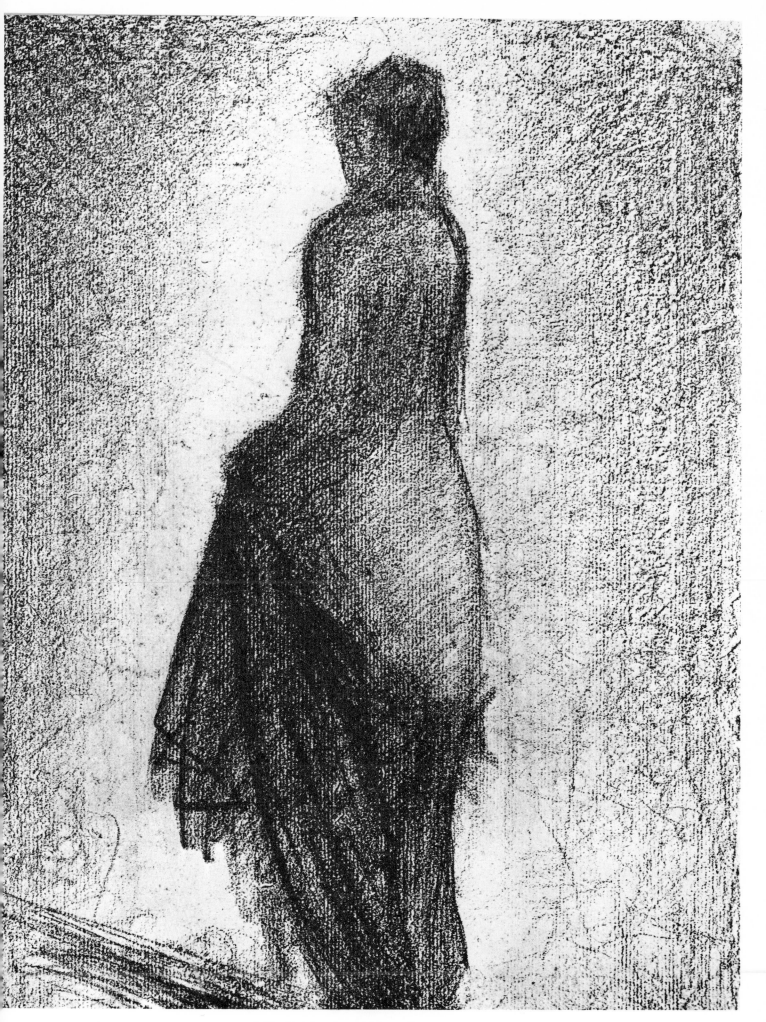

143. Raising her skirts · *Se retroussant*

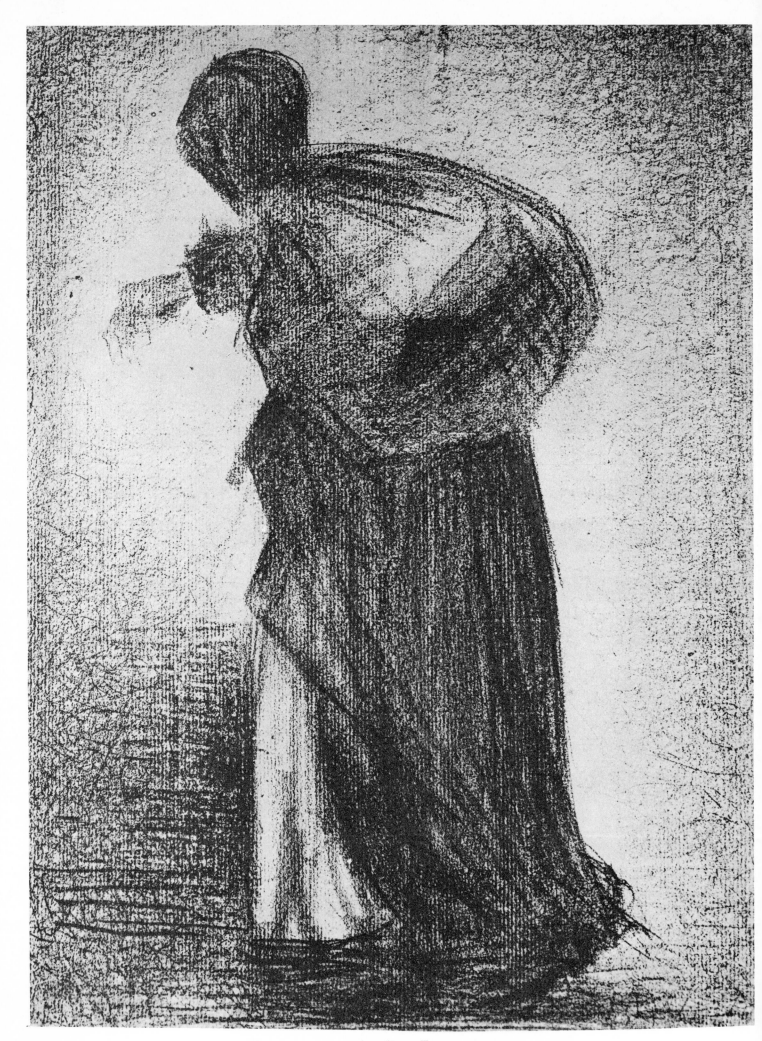

144. Woman carrying a bundle · *Femme portant un paquet*

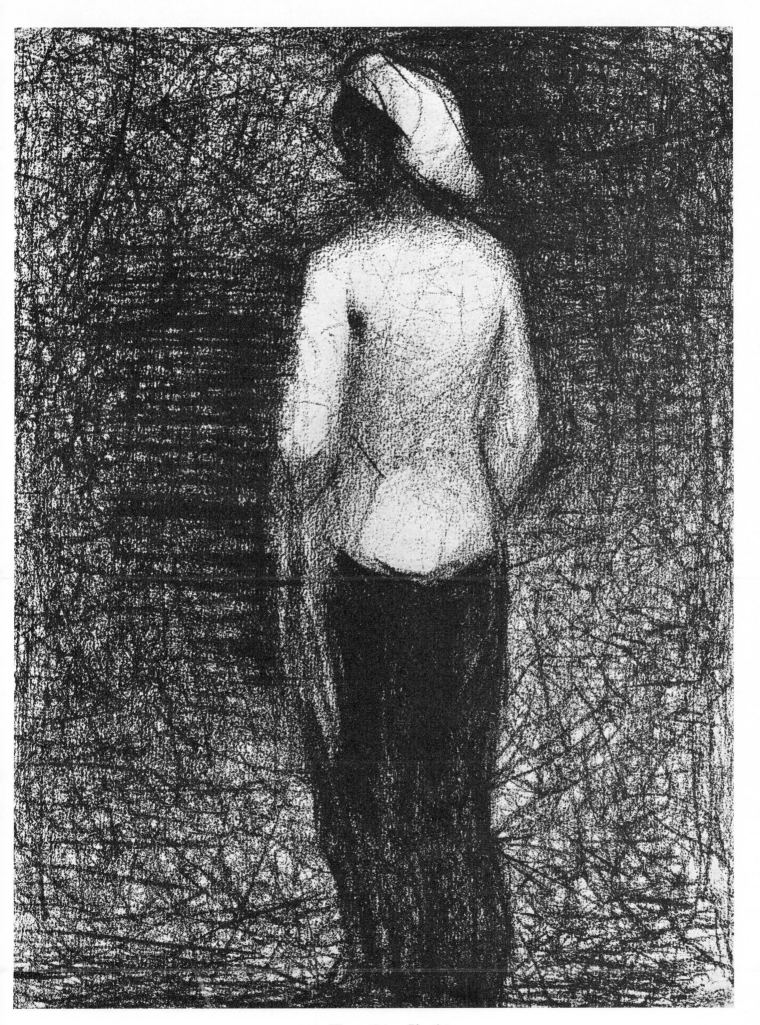

145. The artist · *L'artiste*

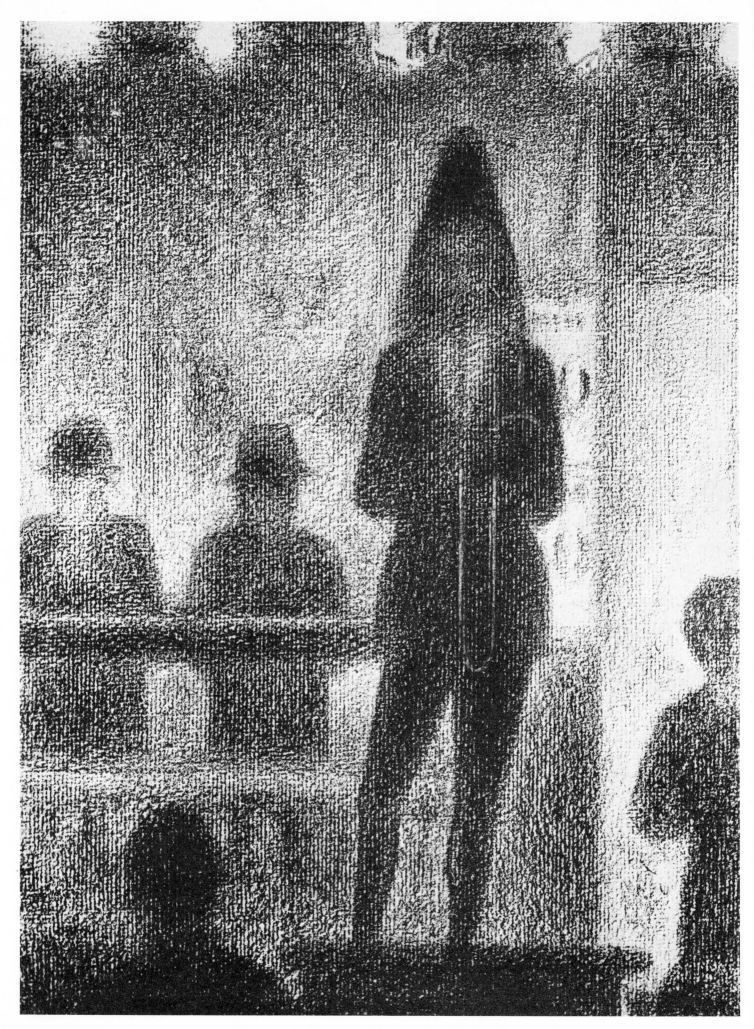

146. Study for "The Outside Show" · *Etude pour "La Parade"*

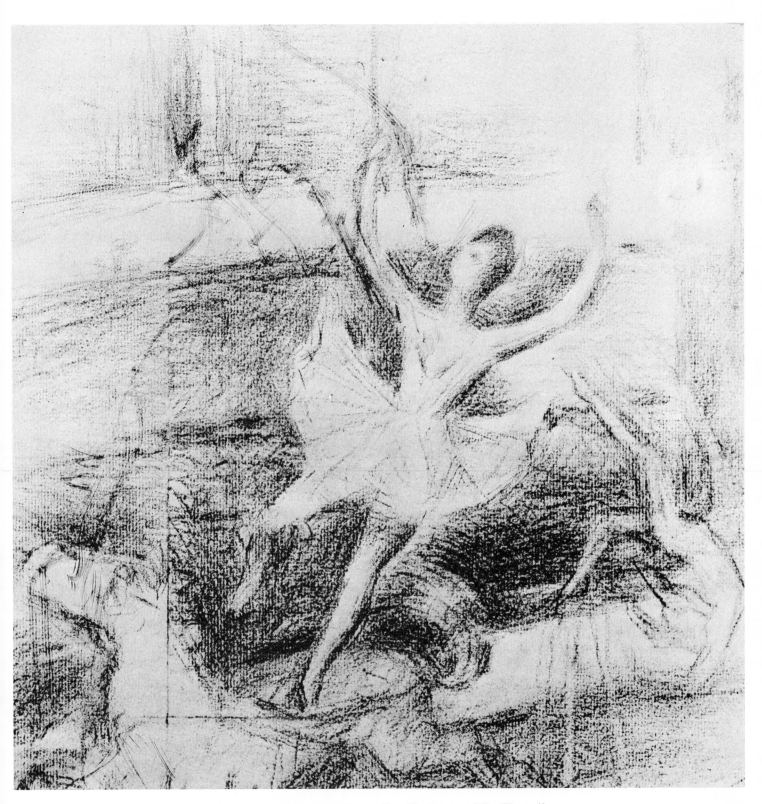

147. Study for "The Circus" · *Etude pour "Le Cirque"*

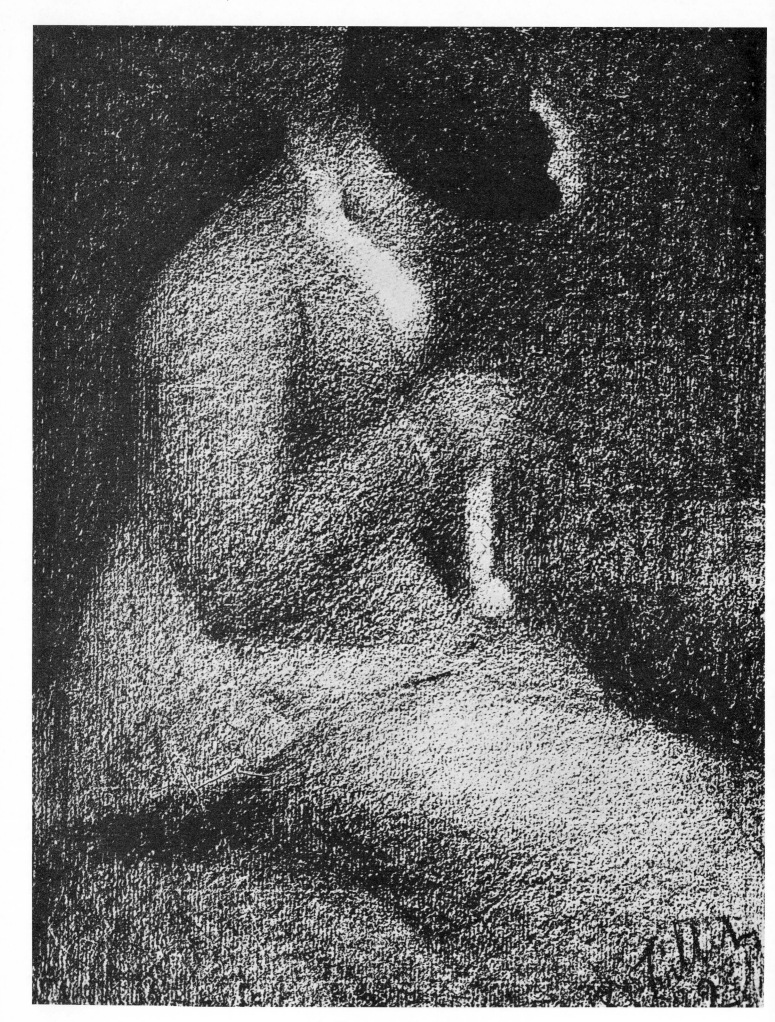

148. Woman sewing · *Couseuse*

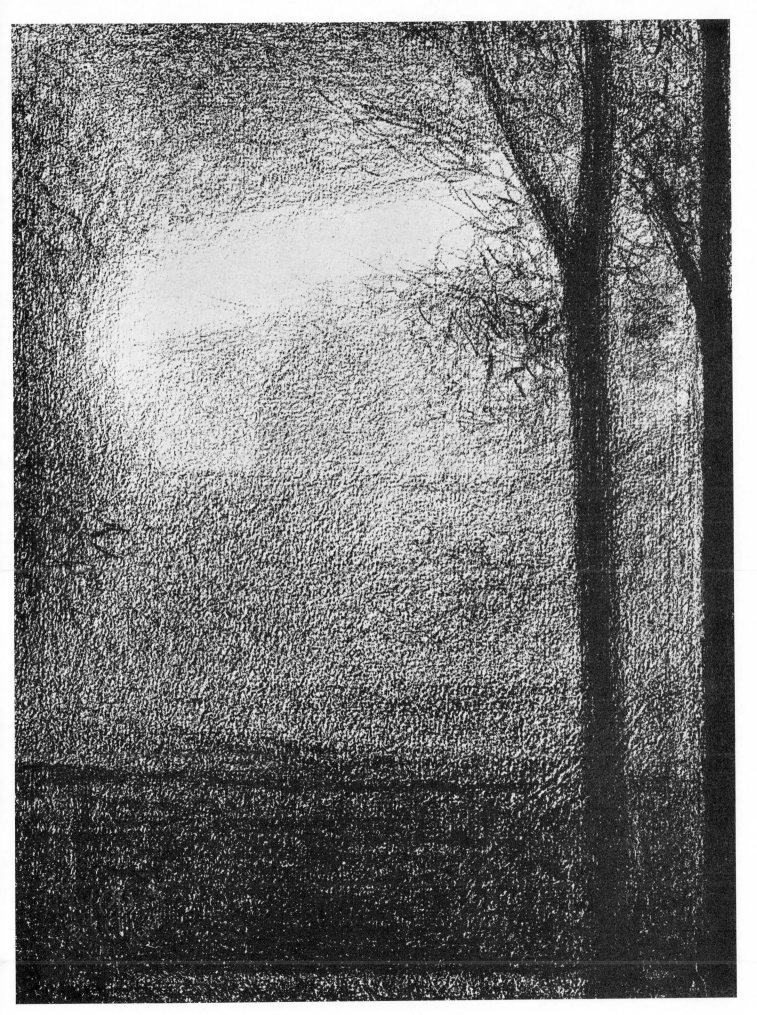

149. Study of trees · *Etude d'arbres*

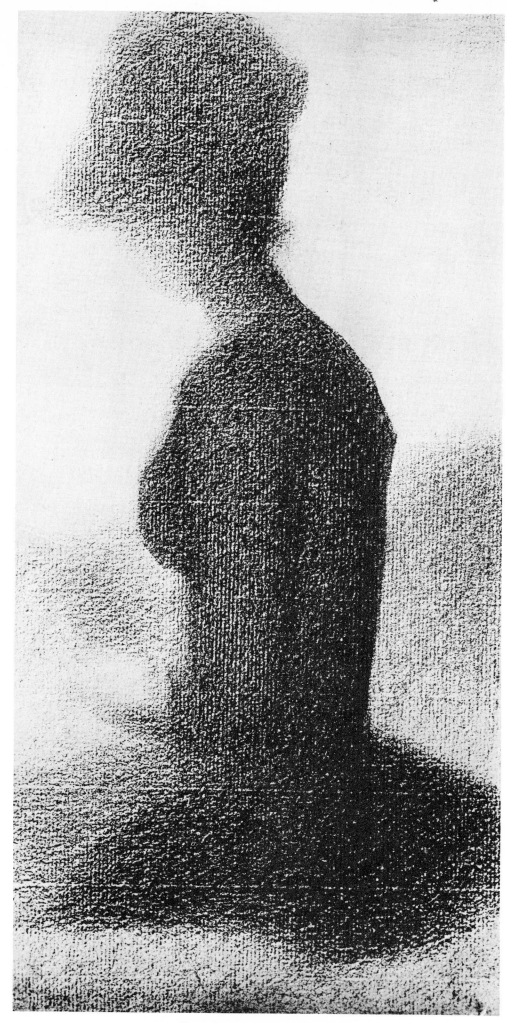

150. Seated woman · *Femme assise*